PICASSO'S PRIVATE DRAWINGS

PICASSO'S PRIVATE DRAWINGS

The Artist's Personal Collection of His Finest Drawings

Including 117 Reproductions

With an Introduction by

Maurice Serullaz

Curator of Drawings

The Louvre Museum, Paris

SIMON AND SCHUSTER · NEW YORK

All rights reserved
including the right of reproduction
in whole or in part in any form
All reproduction rights reserved by S.P.A.D.E.M.
Copyright © 1969 by Simon & Schuster, Inc.

Published by Simon and Schuster
Rockefeller Center, 630 Fifth Avenue
New York, New York 10020

First printing
SBN 671-20383-5
Library of Congress Catalog Card Number 74-87142
Manufactured in the United States of America

List of Illustrations

PICASSO AND HIS DRAWINGS

*I paint things, not as I perceive them, but
as I conceive them.*

PABLO PICASSO

PICASSO's re-creation of the plastic arts has perhaps dealt the deathblow to our belief in their ability to offer a perceptible illusion of reality. His simple, expert work, which is at once spontaneous and controlled, exhausts, if not all the world's forms, at least a great many of the plastic possibilities of the themes undertaken. At one moment a Picasso creation, full of surprises, may make a viewer feel that he sees exactly how any given object ought to be presented, or represented; then the artist, as if in play, immediately proposes another vision, different from the first and yet similar in spirit.

We shall discover that this task of re-creation has one profound goal: reality. Could this have been achieved with the pure outline of a linear style of drawing? Perhaps. For, when faced with the universe that his lines reveal, Picasso the draughtsman moves from one discovery to another, from lightning expression to tireless verification. What does he verify? Prodigiously inventive and extraordinarily capable, he devotes his energies to Truth, the truth of matter and the truth of Art. The truth of his own viewpoint and the truth of ours. For Picasso, drawing stands at the crossroads of the paths that lead from himself to things, from things to the principles of eternal man, and from things to their artistic expression. His drawing, in addition to being a work of beauty, is also an affirmation of the basic and ambiguous relationships between reality and graphic creation, between the theatre of the universe and the handwriting of art.

Picasso creates in the present, with all the strength of a powerful and inquisitive temperament, without nostalgia and without regrets, although not

without repetition. A stubborn explorer, he discloses, by means of resemblances, the multiform ties that attach his contemporary and original viewpoint to the world. His drawing, dedicated to research and experimentation, distinguished for its innate "perfection" and finish, is a means of expression worthy of his genius. Whether or not we consider the graphic work inseparable from the rest of his oeuvre, its field for experimentation, it remains an autonomous form of disclosure, rich and sufficient unto itself. In it the quest for beauty is also a quest for knowledge and sometimes, also, for what we may call a personal ethic, either of a sensual pleasure or a tragic appeal.

Because he seems to reject completion as soon as he attains it, Picasso's activity as a draughtsman is a constant questioning, a trial run that is in no way inferior to its goal. It is a means of conjuring up the surprising face of a poetic, carnal, and artistic dual reality that is inscribed within the hearts of objects and of the artist. Picasso plays with new aspects of the things most traditionally analyzed by artists, much as he demands of us a fresh understanding. We may compare him to the greatest in the past for, generous in his modes of expression, this solitary explorer makes use of all the pages of pictorial history, the better to impose his own corrosive vision. And whether he imitates or revives, he is always original.

The greatest charm of his style lies in its apparently simultaneous innocence and adequacy to the suggested object. Beyond the fact that his drawing has certain great specific qualities, on which we will have to enlarge, curiosity and passion, even the delivery of a message about life, are inseparable from the outpouring of his basic line, the fundamental element, useful as well as beautiful. This is why, in discussing the drawings, it is a bit artificial to dissociate techniques and themes, for they give birth together to artistic expression.

What then is our interest in these lively drawings, which are often careless of relief and perspective—not because these trouble Picasso (he has submitted to the rules often enough) but because they lie outside the destructive and creative purpose of an art that seeks rather to enchant the senses, convince the mind, explore the universe with pride and humility, than to "represent"?

The importance of drawing in and for Picasso's work is all the more remarkable since the graphic outpouring is the primary link between objects and his art. That is to say, practice with form is associated with the daily life of an indefatigably alert workman. Picasso draws and thus re-creates everything to which life attaches him, everything he encounters. His sketches accompany him; they are studies of beloved women, of picturesque characters, of familiar animals and ordinary objects before their mutation into an epic world, figures from classical mythology, legendary creatures, a strange bestiary, or a repertoire of symbolic objects. Picasso is first the lucid and pitiless friend of all that surrounds him.

It goes without saying that drawing techniques are a test of forms used in pictorial creation, "Painting," says Picasso, "makes me do as it desires." Not, however, without an accumulation of sketches, metamorphoses, and preparations. The study of an object, the search for a suggestive line, even if these have been undertaken gratuitously, may lead nevertheless to a pictorial elaboration; or else the drawing may be incorporated into a larger composition, which is in turn finalized through multiple studies of the placement of forms or large colored masses. There is thus scarcely a painting that is not the end product of numerous and varied studies, that does not proceed by accumulation, successive rejections, isolation of the essential, or regrouping of forms. In this sense, Picasso's drawings have a destiny: originally aimless, they provide the necessary intermediate step that connects a man's glance with what is on the canvas.

The drawings constitute an autonomous universe of incontestable wealth, primarily for their original spontaneity, their independence, and their strength. There is no vision or "idea" of Picasso that does not appear first in a drawing, in the imperious and tractable line to which he cedes, submits, and imposes his will, and from which he finally sets himself free. Respectful of a kind of magic that the universe inspires in him and for which he is merely the instigator and the artisan, he is also, right before our eyes, a demiurge of whom we never know whither art, fantasy, and truth will lead him.

We will return to the techniques and mediums proper to the drawing,

but at this point we may note in it certain elements found in the painting, even in the sculpture and other objets d'art. Picasso's drawing has the breadth and deep breathing of his painting, its solid framework and its construction in planes. Sometimes, he husbands the large flat areas for which he has a predilection (or, at least, had until recently) . In the absence of relief, he is still able to indicate volume and to give consideration to shadows and gradations of light and tone. Sometimes more intensive than the paintings, the drawings are often accomplished in a primitive line, rigid or wonderfully supple—which may be sacrificed to vivid color in his paintings—and dissolve into harmonic modulations. Extraordinarily moving, he blends cubist precision with expressive, uninterrupted movement.

It would be pointless to compare Picasso the draughtsman with Picasso the sculptor, for the latter bends easily to the exigencies of the materials he models or the heteroclite objects he brings together. Nevertheless, in addition to a correspondence between certain thematic and expressive experiments in both activities, Picasso's drawings have a monumental aspect, a placing of luminous contours in relief that frequently reminds us of an inscription of forms in space, as if the drawings were deliberate, considered projections, sometimes geometric and sometimes quivering, of the manner in which objects, ordinarily unoutlined in nature, clamor for line to enclose their structure.

It is not in a spirit of denigration that we stress the deliberately decorative aspect of the drawings. This aspect may be noted also in Picasso's folded metal work and in his ceramic plates and vases, while it is in his large theatrical designs that he finds his broadest and most spectacular expression. One of his major merits is this ability to conserve his self-assurance and his flexibility, his authority and his moving grandeur in every form of art.

What Picasso owes to drawing may be especially noted in the field of graphics. Since he cannot make use of the subtleties of wash in this domain, he utilizes a strength of line and a freedom in cross-hatching that make it difficult to dissociate the graphics from the drawings. We are aware of how much each owes to the other and know that they run parallel courses in their evolution.

However, since our discussion here must be limited, let us simply return to the magic of the drawings, bearing in mind that the entire body of work of this turbulent, devoted talent depends upon it.

It is undoubtedly as fascinating to watch Picasso at work as it must have been to watch Michelangelo, Rembrandt, or Delacroix. But as far as Picasso's drawings are concerned, we are privileged to be able to follow modulations of the creative gesture, if not the gesture itself, from the starting point of a plastic statement through many variations—or, what amounts to the same thing, through variations on the same theme. With Picasso as with Michelangelo, a conjunction exists between imaginative line and pure drawing. According to Baudelaire's categories, a pure draughtsman is primarily a naturalist who seeks to outline objects and their details, perhaps even innocent of stylization; the imaginative draughtsman is primarily a colorist whose drawing is revealed essentially at the level of the concerted logic of its lines. But it is possible that a great artist, even one who is not a colorist, may possess an intensive power of broad and poetic drawing. This is certainly true of Michelangelo and sometimes of Ingres. And this is surely a seductive explanation of the fact that realism, expressive deformation, and an inevitable rightness are all found at the same time in Picasso, the draughtsman. When we look closely we note that his most suggestive modulations, his most daring shortcuts exist within a total harmony that he apparently sees even before he begins to draw. He remains the structuralist of the Cubist period, even in his most fluid and most paradoxically synthetic drawings, slipping his caprices and inventions into irreproachably organized pages.

And these audacities, which do have their limitations and do fall into place, depend on a style in which a firm, continuous line, as we have said, is a fundamental element. In this sense, Picasso is not lyrical like Delacroix, whose strong line is most often born among shadows and entangled arabesques, whose general rhythm springs forth suddenly between areas that are shaded with cross-hatchings and areas that are left luminously blank. Any lyricism that may exist in Picasso's work is mysteriously imprisoned, even in

the most undulating and freest of his drawings. In other words, the freedom of which Picasso is master corresponds to no lyrical technique comparable to that of Rembrandt or Delacroix. Why do even Picasso's most dazzling fantasies seem to us to depend on a judicious strength and poetry? In truth, his fondness for purity and classicism often makes us think of Ingres. Like him, Picasso loves beautiful Greek statues and strong profiles. This love and this rigor are not contradictory, even in his expressionistic faces; they make the best of the core of cruelty and the vigor in the artist's work, which may result from his Spanish background, in any case from his interest in pulsations of flesh and blood, in the chilling powers of sorcery . . . and in nineteenth-century art.

The last remark evidently supports a comparison with Goya, the draughtsman and graphic artist who cowered away from the world and its horrors, and from the pressures on the imagination faced with them. But in our century, Picasso, even in the agitation of his formal creativity, still retains a somewhat primitive vision. Extremely knowledgeable, he masters at one and the same time the dream and the reality and their fresh, untamed expression. What is extraordinary is that while he questions the great works of the past, he constantly returns to them, explicitly or implicitly. He knows everything and he knows nothing, combines ornamentation with the reconquest of the original relationships between man and the universe, and is the representative of an extremely simple and highly sophisticated art. Like the artists of ancient Rome, he provides simple forms to which he adds the flesh of reality, but like a man of the Renaissance he submits the universe that he catalogues to a salutary geometrical order, and ends—or recommences—by giving it the imprint of the human spirit.

The entire gamut of traditional techniques serves Picasso's incomparable talents as a draughtsman. He draws his principal outline—a line as faithful to the obvious as to the artist's dialogue with it—in black lead, pencil, or charcoal. But he requires lights and shadows in this free dialogue. So he chooses various inks, especially India ink, as the medium both for marvelously light drawing and for thin washes and other devices that establish varying relation-

ships between black and white. Even more happily, Picasso, not a thorough artisan in his handling of thick color, uses pastel, gouache, or watercolor to suggest in his drawings the fresh raw harmonies found in his oils. Most important of all, he is adept at combining these different mediums in astounding fashion, at masking the sharp brilliance of his line under light sheets of color. It is not surprising that Picasso, whose style has become steadily more and more generous and broad, has during recent years been accumulating in his portfolios fluid works drawn in pencil and touched up in colored pencil. The style of these drawings is more one of direct perception and artlessness than is the case in those dominated principally by India ink.

It is noteworthy that in Picasso's direct execution of the scenes or dreams he evokes, an important part is always played by experiment and research. The procedures he uses, and the repeated variations to which he devotes himself, proceed in this way. But we must repeat that no matter how much he plays artistic games with natural laws and appearances, Picasso assures for the forms he re-creates a fundamental, if not always apparent, structure. Form develops upon this solid framework and within firmly ordered space. Doubtless, Picasso's talent for composition is so strong that it finally becomes invisible. Sovereign order indicates control over things and structure is no less important, poetically and aesthetically, than external appearance. This structure—which renders itself invisible, as do controlled volumes—permits Picasso to give free rein to the enticements of outlines. Apparently, Picasso, satisfied with having probed the foundations of objects, with having once more analyzed what supports and sustains them, can then devote himself without further constraint to the fascinations of line and silhouette, whether supple, simple, or baroque. But he knows nonetheless how to use touches of ink or of watercolor to recall the internal life of his objects.

It is true, nevertheless, that besides the interrelations of light and shadow, Picasso's sensitive line conveys the essential tension of temperament, the caprices of an impetuous, sensual, and fanciful personality who goes beyond Beauty and correctness of form, who retains the privilege of dreaming and rambling around what is necessary. To negate the role of play in the creation

or interpretation of forms is to deny at the same time the contributions of curiosity and of pleasure. But in Picasso's work, form is not completely gratuitous, nor is it ever merely pleasurable. It conserves and even increases the power of the object that constitutes its theme.

This is why the verification of his own discoveries through drawing, the materialization of the man's judgment and sensibility through such direct means can be associated with themes approached. The work is so lively and so animated that one obsessive theme may be handled in very different styles in widely separated periods. However, the object itself changes according to the manner of its presentation, or rather manifests itself differently, takes a different position between still unexplored nature, substantial or dreamlike, and "styles" of drawing that are so many revelations of their creator and of nature itself, nature as seen through Art, through the intelligence and the imaginings of an artist of genius. Some aspects of the aesthetic and thematic development of the drawings must therefore be stressed.

Setting aside the drawings done before 1900, those of the Blue and Rose Periods already manifest a limpidity, firmness, and boldness of line that will remain characteristic. Moreover, in antithesis to the contrasts in shading of the graphic transpositions of the Blue Period, there are as early as 1902 attempts at "classical" nudes in a clean, free, and light line. The rougher and more stylized studies of 1907–8 lead toward another rigorous purity, seen most clearly in the Cubist drawings of around 1910, and reappearing ten years later. Principally, however, he derived from these explorations that taste for internal structure which we were discussing, and a cleanliness of "external" line that lends such importance to the portrait drawings of the 1920s. The same years saw the development of Picasso's "classical" taste. In relation to certain themes, such as that of feminine beauty or those born of mythology, this taste will never leave him. Yet the forms of this period are often enough handled in a manner that preserves modeling and emphasizes volume. Others, however, offer already the simplifications and audacities that will later come to light, decorative in the unadorned still lifes of 1924, bubbling with lyricism

in the figures of 1926–35, whether these are surrealist in inspiration, whether they join lightness and felicitous foreshortening to pagan naturalism, or whether, inspired by the bullfight, they involve the appearance of the symbolic, hallucinatory, and tragic theme of the Minotaur, along with that of violence and war.

Expressionistic and fantastic elements do not prevent Picasso from returning to classical themes, nor from developing the expressive stylization of women's faces, nor from managing better and better to relate shading to the virtuosities of his lines. After 1940, female nudes, bullfights, still lifes and portraits profit sometimes from geometric stylization, sometimes from the most spiritual line, delicate, clean, and modulated. Processions of animals or of knights, allegorical or mythological scenes, variations on a woman's face, on a painting by Delacroix, on a landscape, bullfights—what do we need to remember of Picasso's fecundity after 1950 other than the enormous variety of his themes and his styles? We can at least note, in his most recent works, the frequency of the theme of the female nude—in the *Bathsheba* variations, for instance—and the lyricism of a draughtsmanship that is often baroque, nervous and simple, unexpected, dynamic.

We have indicated how calculated and introverted this lyricism is, to what extent aimed at the essence of line, of form, of "subject matter," and Picasso's freedom of style is deliberate, of ambience. If the drawings are characteristic enough to give an idea of the entire oeuvre, it is also true that they provide a sampling of the *objects* that the artist chooses (or that his life imposes on him) and of his *subjects*. This clear and spontaneous expression—in which and through which his forms are born—constitutes a constant revaluation of ideas and visions, as well as the proving ground for important aesthetic options preparatory to painting.

Picasso tests all the major directions of art in our century, and his variety is such as to make it impossible to compare him to one or the other of his contemporaries. Classical and expressionistic, naturalistic and imaginative, passionate and epicurean, tormented and sensual—he creates symbols and submits what already exists to a symbolist vision. He invents monsters and exalts man

and love, in a world that is sometimes happy, sometimes haunted by evil. Nevertheless, even when he appears to be involved in the domain of irreality he always returns to the reality of man. Significantly, the Nature that he draws is not simply that of the human figure, but also one based in anthropomorphism. For if, in Picasso's work as in Goya's, man is transformed into a bestial creature of the Apocalypse, into a grotesque or frightening monster in the mythology of war—sometimes in the mythology of love—in their turn the animals of Picasso's bestiary remind us of man and of his violent beauty.

These drawings contain—as a supplementary theme, on the level of pure Art—a transition to a secondary consideration, a consideration of Art itself, of "models" and of techniques. Picasso wishes to describe and express himself both as man and as artist, so that beyond the explicit subject of each drawing is another: *The Artist and His Model*. Across all the feverish metamorphoses of style, not to mention of theme, lies an expressive efficiency and a questioning of aesthetics. Finally, talking of himself becomes talking of man, telling of the world becomes the attainment of the universality of an art that indeed elucidates many aspects of the world, many aspects of life.

What then is the ultimate unity of these metamorphic drawings, what links them together through all their dazzling avatars? "I have wished," says Picasso, "by means of drawing and color, since these are my weapons, to penetrate ever further into knowledge of the world and of men, in such a way that this knowledge might free us more each day." The ephemeral and changing line thus penetrates into the heart of things in a thousand ways. It is impressive that the linear firmness of his draughtsmanship—or, in other cases, its patient superimpositions of line and shading—always gives the impression of a victory over reality, of a fiery but continuous opening onto a universe that is constantly changing, constantly and feverishly being taken apart and rebuilt in a perpetual evolution, a universe where nothing that is said is irrevocable, where artistic activity is a means of imposing the stamp of the human spirit. For the constant questioning is followed by a new architecture of nature, and it is precisely through his tireless variations that the artist acts upon this.

Face to face with Nature, Picasso is at once exalted and reasonable, pantheistic and humanistic. Beyond aesthetic pleasure, this great art holds one—or several—meanings for the artist, for the observer, and for the thing portrayed. It speaks of man's position vis-à-vis the universe and his own destiny. It also speaks of Art itself. In the huge body of his work, Picasso seems to take the measure of reality and to suggest a hundred different ways of speaking, each invariably resulting in the truth; he maintains an equilibrium of direction and of form, yet, as if uneasy, passes from a tested formula to a new manner that will in turn not suffice for long, as if there were mortal danger in coming to an end in his artistic exploration, with its myriad methods. He knows that the aesthetic order that he imposes at any given moment is as fragile as that which we think we see in things.

Drawing is for Picasso the very heartbeat of creation, the first fruit of suggestions offered by the world, those offered by observation and by inspiration, and finally those offered by the accidents of drawing and techniques provided by unsullied and knowing hands. In a tragicomic universe, Picasso—as visionary and as lover of life—celebrates in turn terrible festivities and fleshly joys. But, breaking away from his own certainties and harmonies, he changes the setting and the actors of a spectacle that is begun afresh. In other words, it is difficult to know how much in his daily work is due to caprice and how much to conscious effort; but at least it is certain that it is useless to talk of *pure art* in reference to work that is so concerned about its ultimate aim, work in which a calm beauty reflects the beauty of the world, in which an astonishing, even frightening expressivity reflects a sensory fear, the shock of a raw, passionate vision.

There is no art that does not reflect some traces of morality, that does not depend on the reorganization of these traces. It is curious that Picasso is so fickle and refuses to relax with just *one* form of art that would seem to defy death and transience. But he has chosen to evolve as reality does and to try to equal the variety of the universe by varying his symbols and motifs. This is not without insuring himself some permanent foundations in his activity, which involves action as well as reflection. There is no intellectualism in him, but his

spontaneity and imagination constantly verify the effects of reality upon form and of form upon reality, to the point of reanimating, through art, the things that move him. In this sense, too, Picasso is not an artless artist. His skill and his enthusiasm, his gifts and his fears remind us of our most lively aspirations. And the inspired language that is real art finds here a middle ground between thought, sensibility, truth, and form. Picasso gives evidence and makes us the judges of an activity that refers in every instance to man, of a capacity for continual creation that rejects unity of technique the better to respect the life of the mind and the senses, the interior devlopment of the arist.

For there is also no art without a reorganization of vision. If the freedom that we see in these drawings is sustained by a method, that method is based on the permanence of life and on the perpetual interchange among imagination, the senses, and nature, restoring a fascinating existence to what surrounds us and feeding on it. Everything, in Picasso, moves *with* the universe that molds us to the extent that it is seen by us. Thus artistic thought is rather a participation in the world than a distant reflection of it. Yet we have said that art is the creator of reality and is the noblest possible reaction to the stimulus of the simplest objects. In art, reality and imagination are reconciled; in art, everything is true, in the world and in the drawings. The "handwriting"—changeable and direct, precise and washed out, victorious and uncertain—goes beyond logical inconsistencies. In it, we see the birth of an order, but an order that carries with it its own "incompleteness"; we even see in it an immediate opposition to a system that is eternal but limited. Nevertheless the works remain, like a beautiful and fruitful, rich and intense claim upon us. We see in the "handwriting" the birth of freedom. And since the development of art runs parallel in this respect to the dynamism of life, it is impossible to separate from each other the rough diamonds mined from things, those mined from the resources of art, and those mined from the eyes and the heart of a man who is at once rational and irrational, mysterious and comprehensible.

MAURICE SERULLAZ
(*Translated by Matila Simon*)

Plates

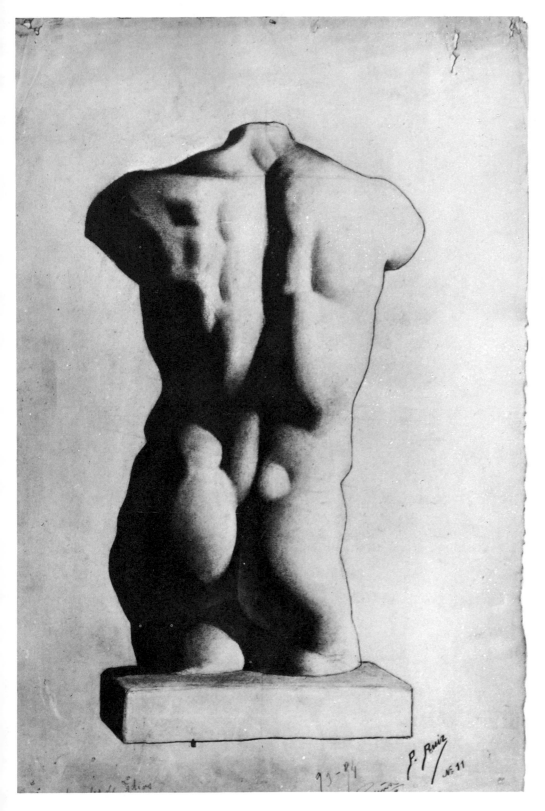

Study of a Torso
after a Plaster Cast
*Pencil and charcoal,
19⅜ x 12½ inches
1893 or 1894*

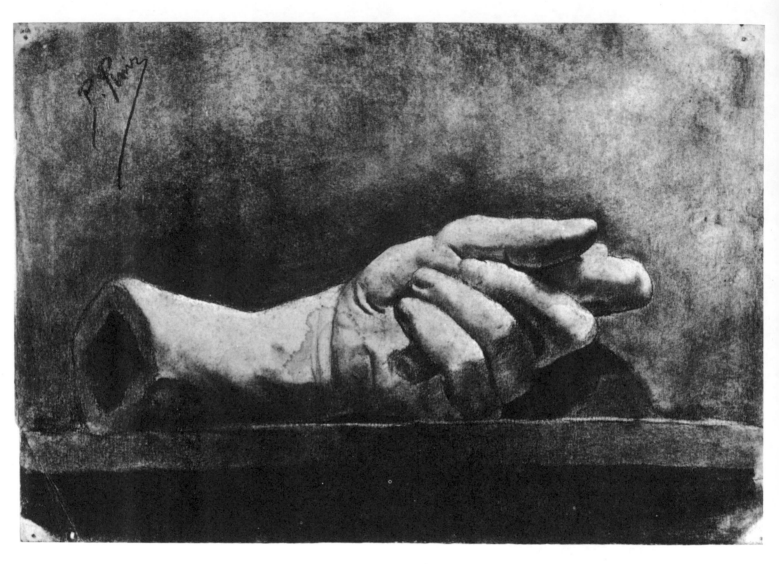

Study of a Hand after a Plaster Cast. *Charcoal, 9⅛ x 13⅜ inches. 1893 or 1894*

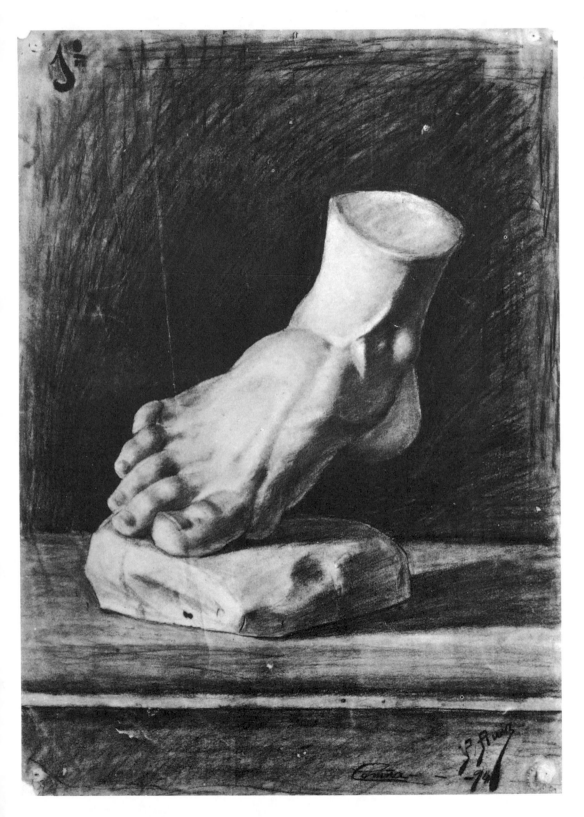

Study of a Foot
after a Plaster Cast. *Charcoal,*
20½ x 14½ inches
1894

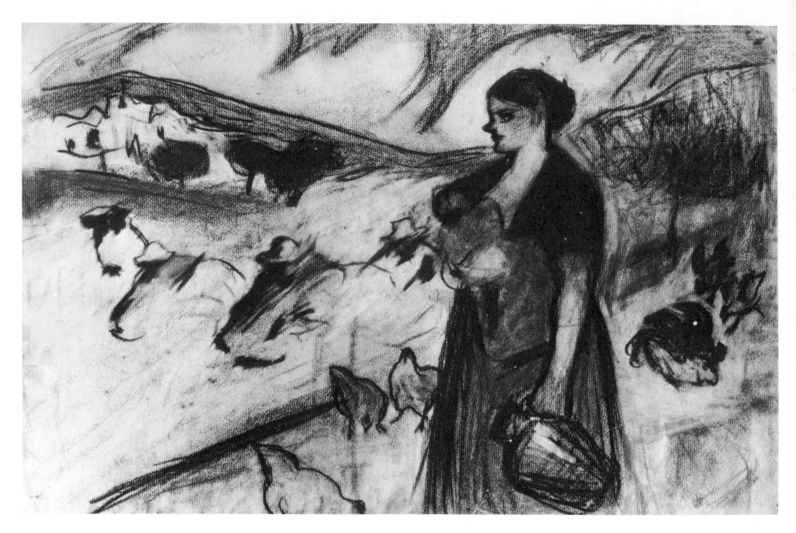

Peasant Woman. *Pencil and pastel, 12⅜ x 18⅞ inches. 1896*

Nurse Suckling a Child
Charcoal and watercolor,
12¾ x 9¾ inches
1896 or 1897

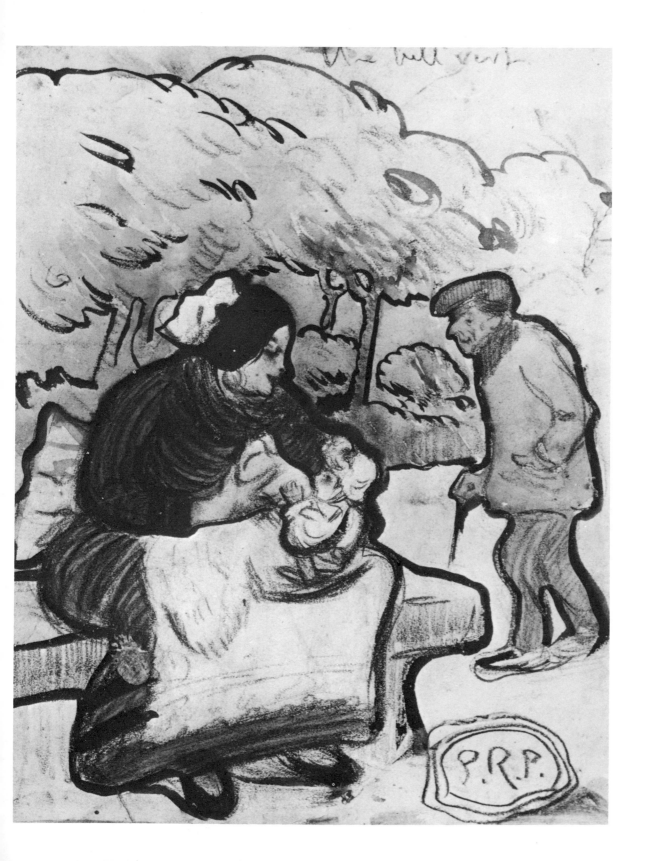

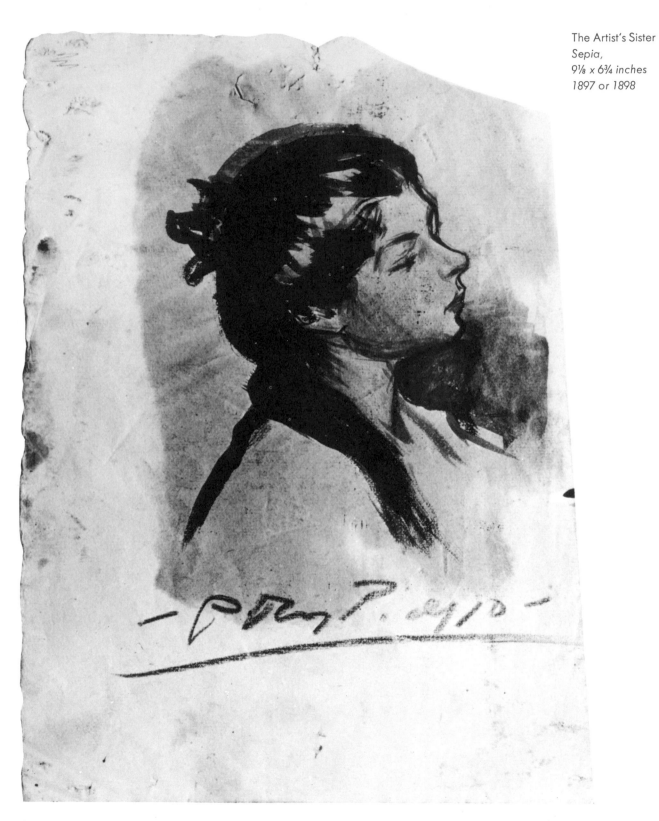

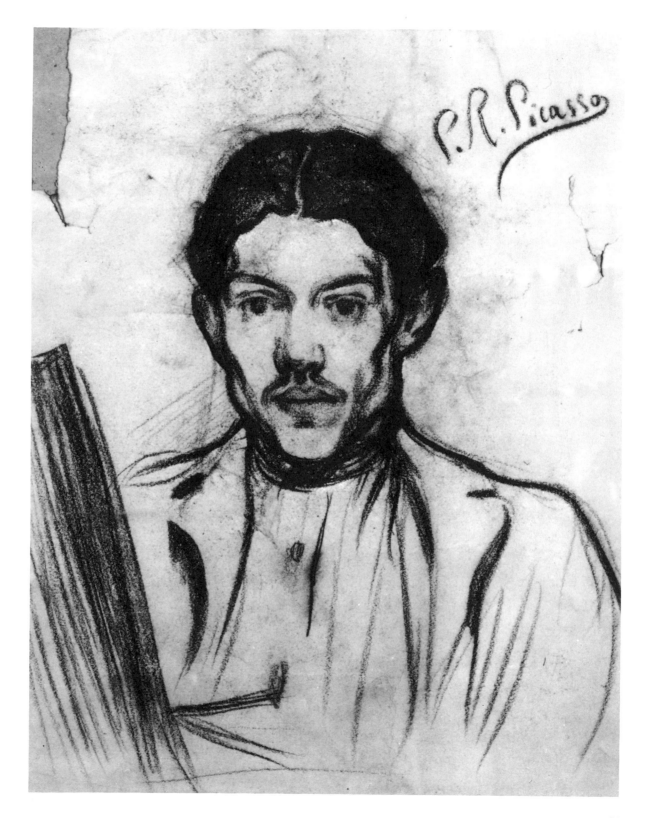

Self-Portrait
Conté crayon,
12⅝ x 9¾ inches
1901

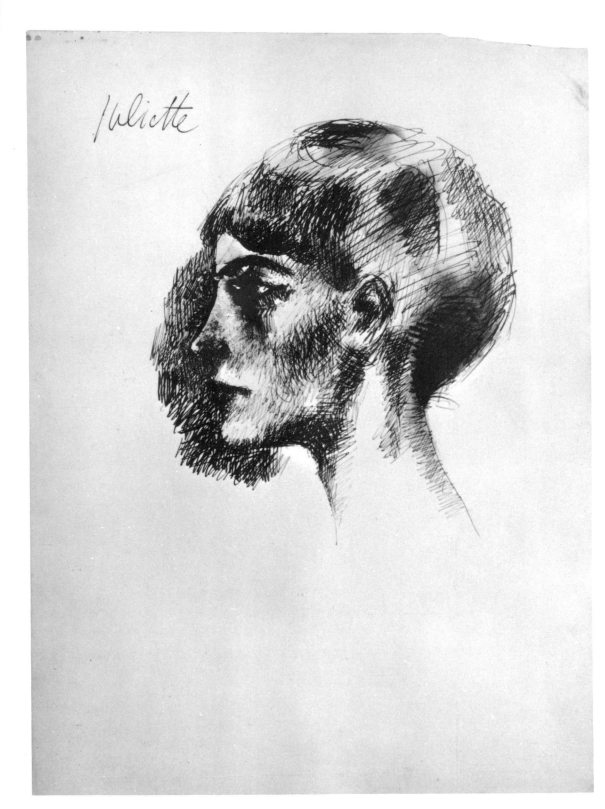

Juliette
India ink,
14⅝ x 10½ inches
1904

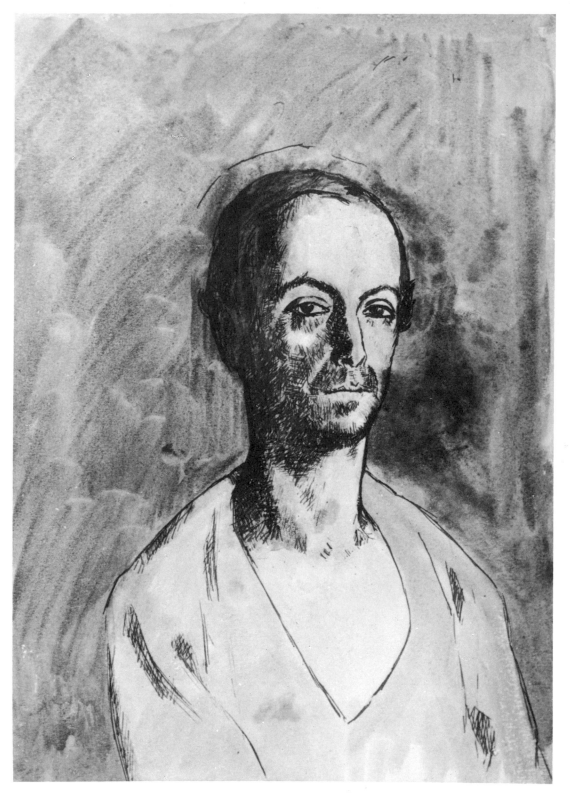

Portrait of the Sculptor Manolo
Ink and watercolor,
14⅝ x 10½ inches
1904

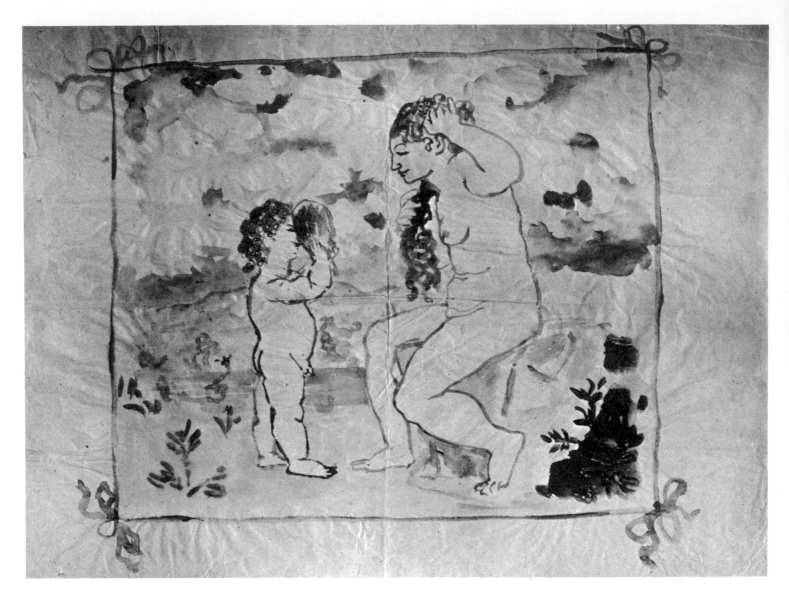

The Toilette. *Watercolor highlighted with ink, 12¼ x 16½ inches. 1905*

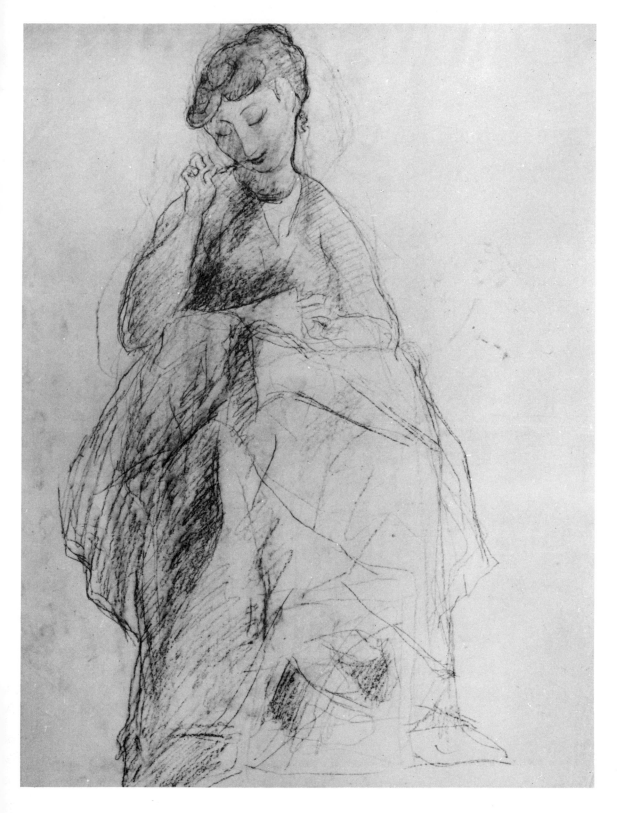

The Seamstress
Conté crayon and charcoal,
23⅞ x 18⅞ inches
1905 or 1906

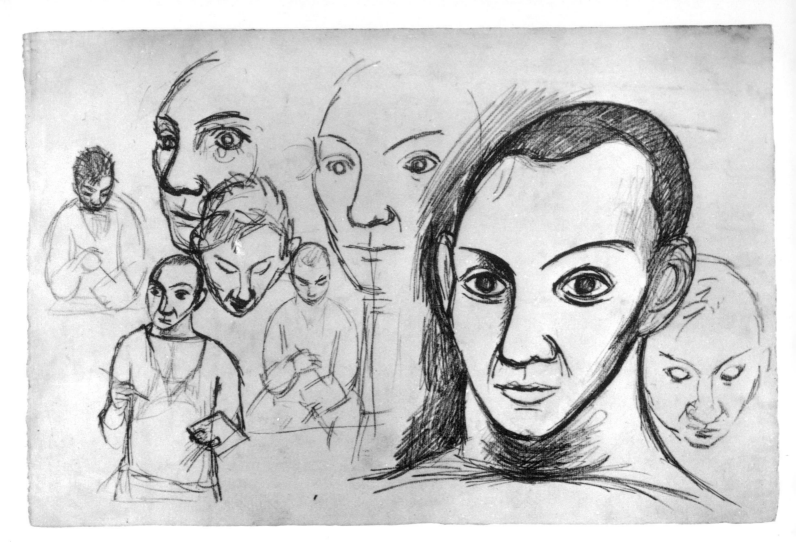

Sheet of Studies for the "Self-Portrait" of 1906. Pencil, 19 x 12½ inches. 1906

Study of a Man
for "Les Demoiselles d'Avignon"
Gouache,
25 x 19 inches
1906 or 1907

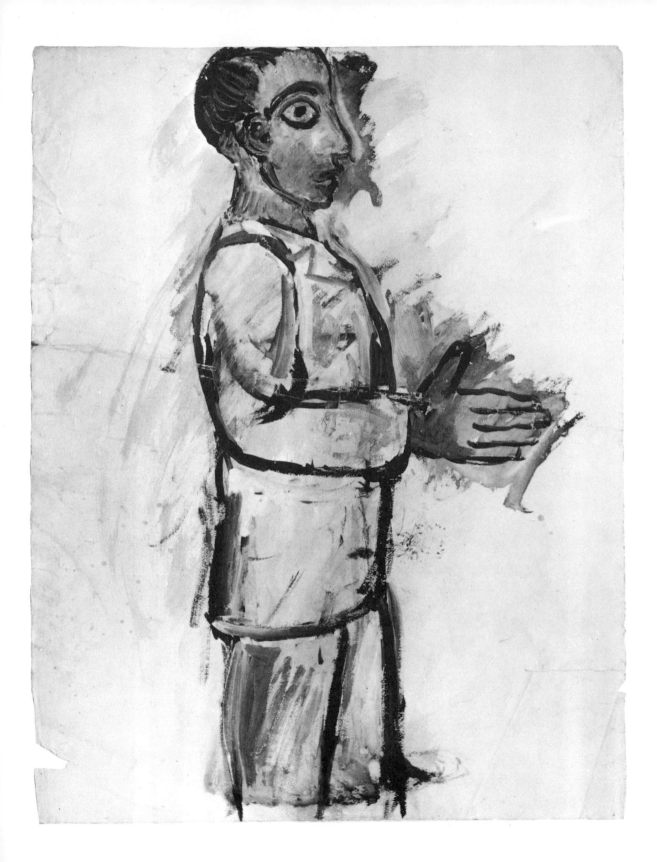

39

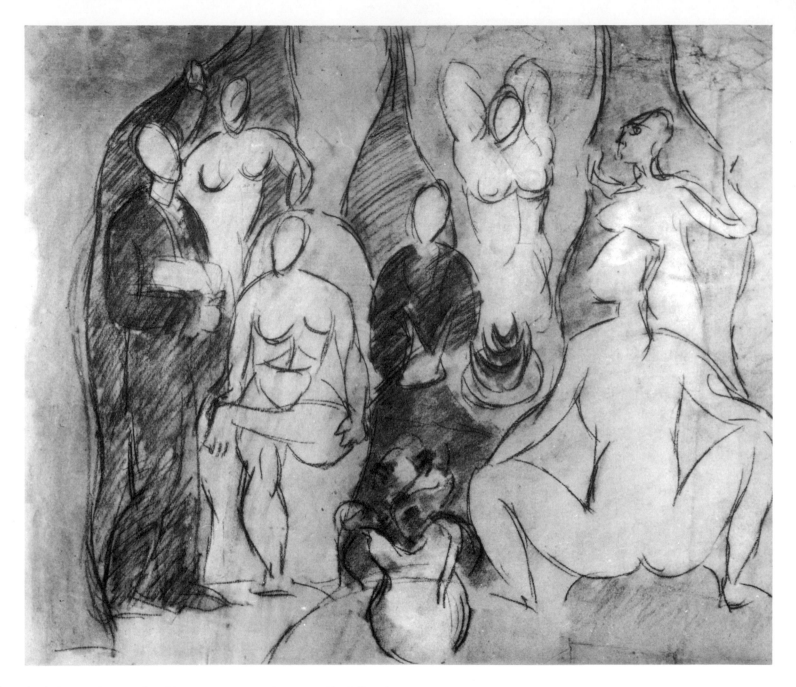

Study for "Les Demoiselles d'Avignon." *Pencil and pastel, 18½ x 24⅝ inches. 1907*

Reclining Nude Woman. *Pastel, 18⅞ x 25 inches. 1907*

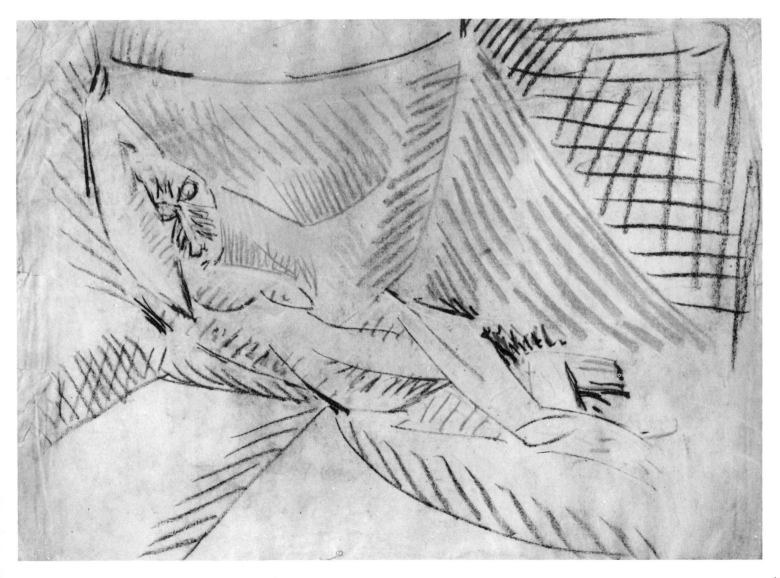

Standing Woman
Pencil and watercolor,
24¾ x 18⅞ inches
1907 or 1908

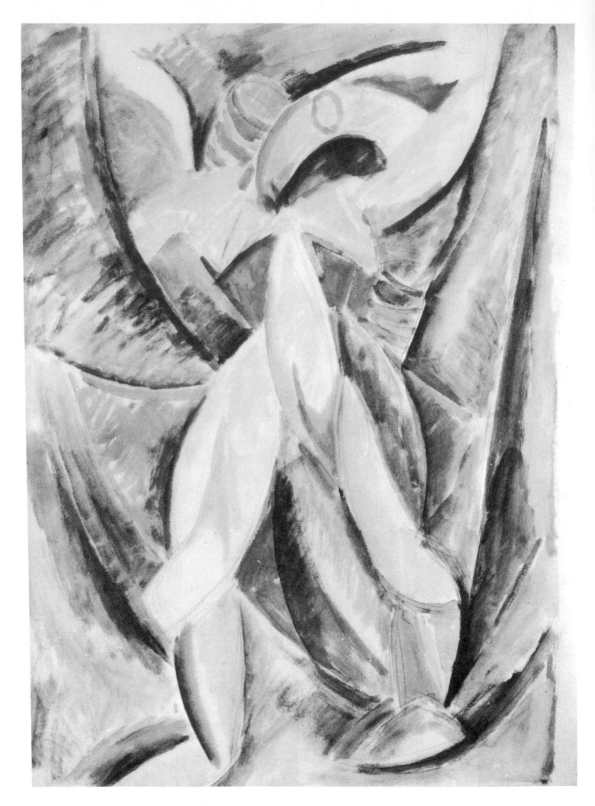

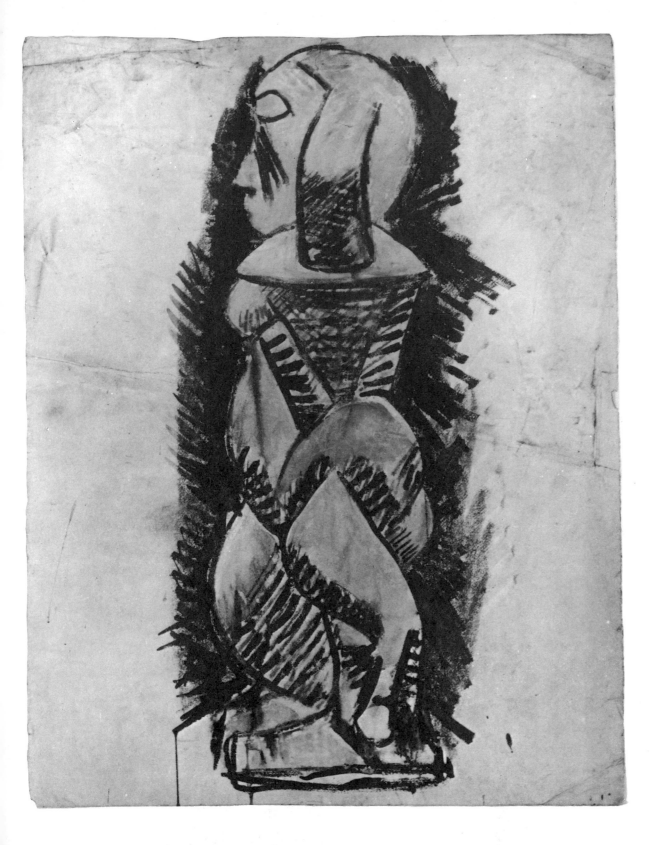

Standing Personage,
in Profile
*Pastel and watercolor,
24¾ x 18⅞ inches*
1907

43

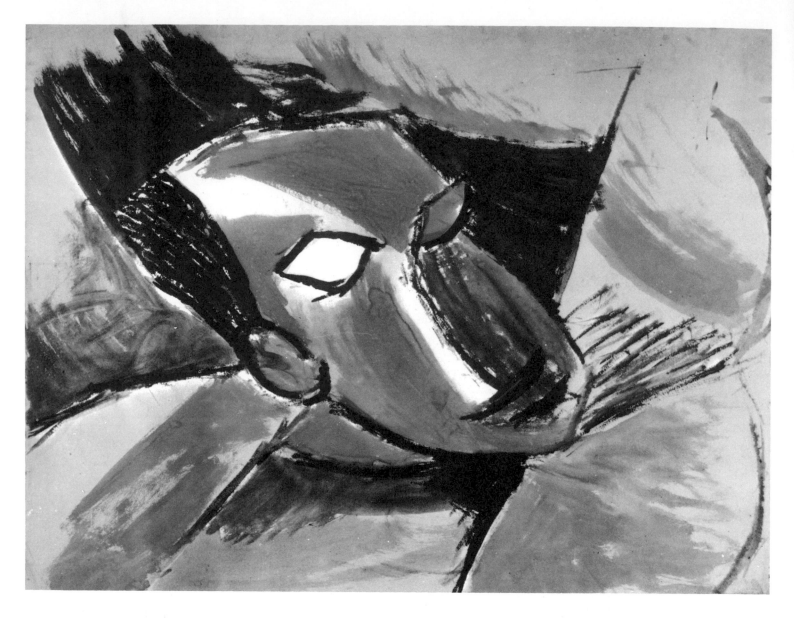

Head of a Man. Gouache, 18⅞ x 24¾ inches. 1907

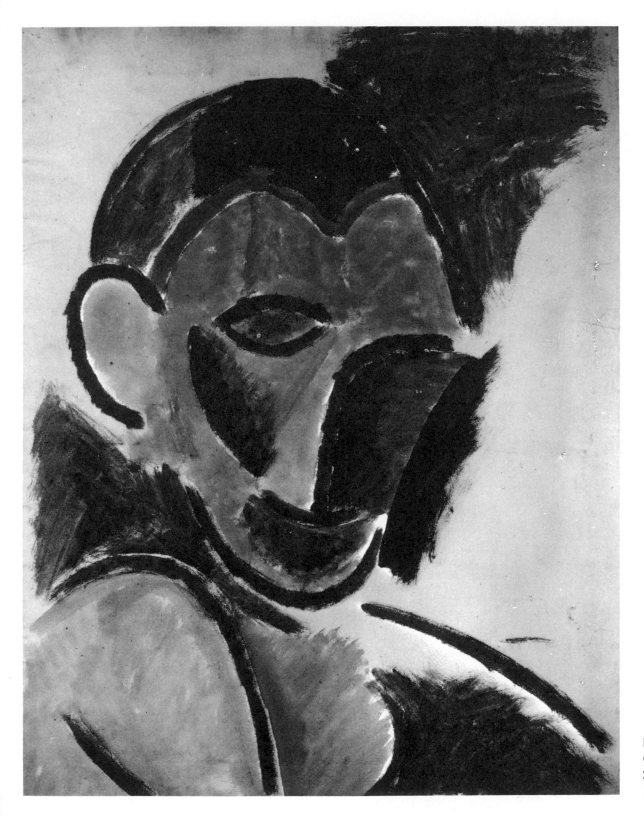

Head
Gouache,
24¾ x 18⅞ inches
1907

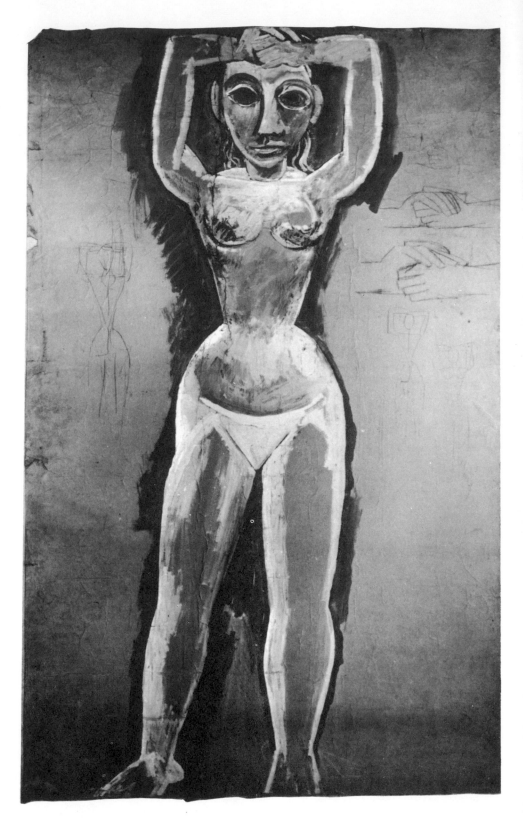

Nude Woman
Seen from the Front
Pencil and gouache,
50⅝ x 30⅞ inches
1907 or 1908

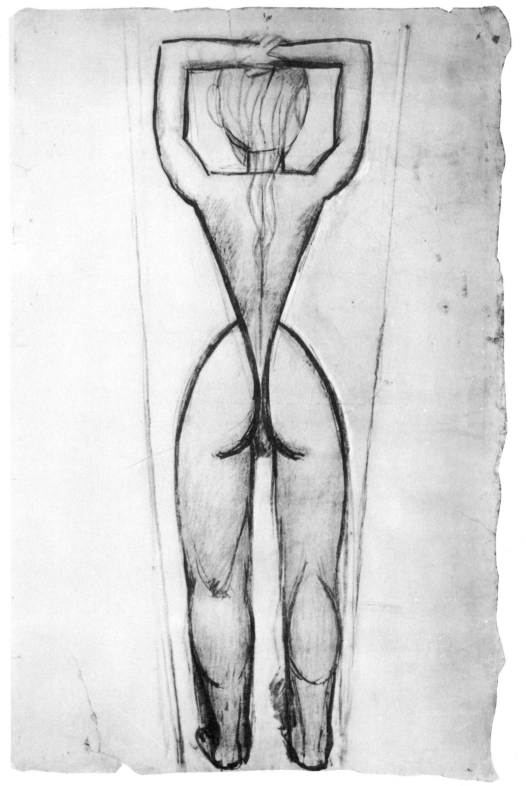

Nude Woman
Seen from the Rear
Charcoal and gouache,
52 x 32⅞ inches
1907 or 1908

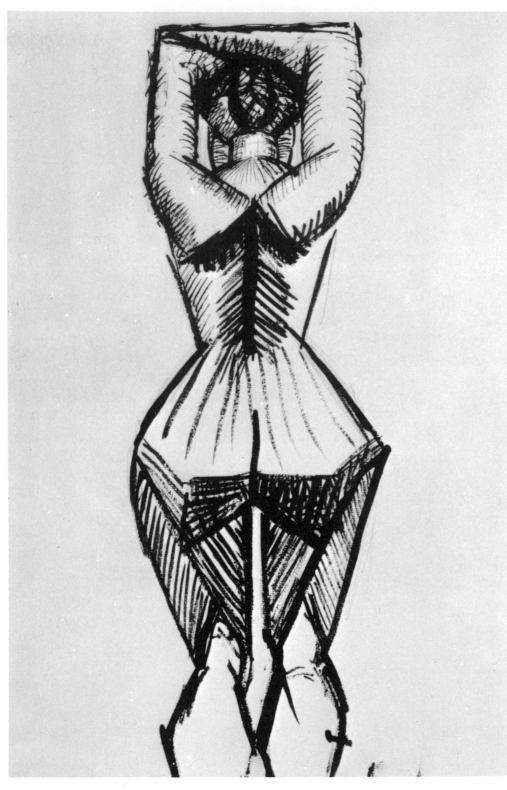

Standing Woman
Seen from the Rear
India ink,
18⅞ x 12⅝ inches
1908

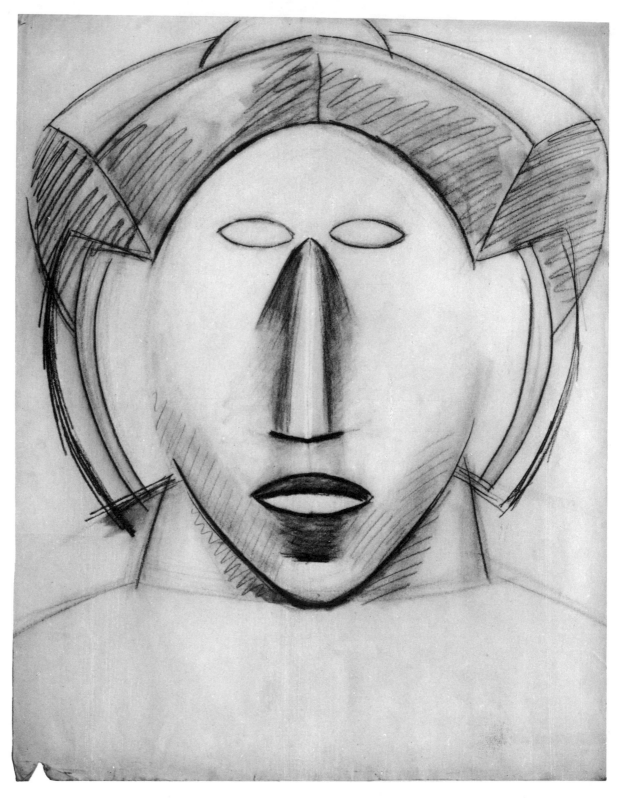

Head
Conté crayon and charcoal,
25⅜ x 19½ inches
1908

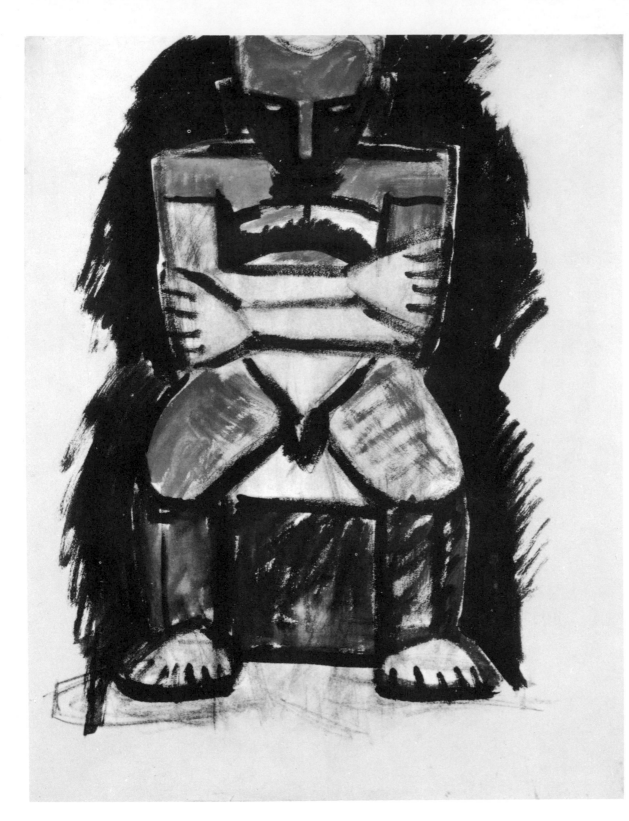

Seated Man
*Charcoal, gouache,
and India ink,*
24¾ x 19⅛ inches
1908

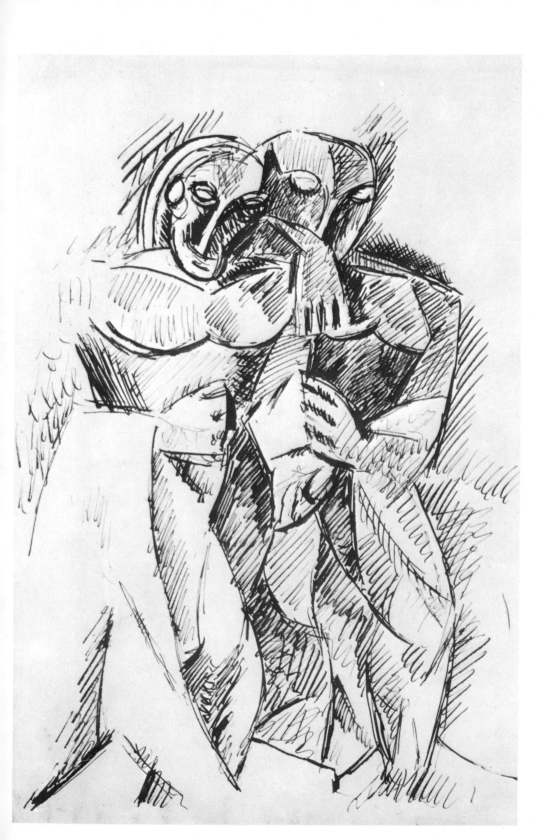

Friendship
India ink,
19 x 12⅞ inches
1908

51

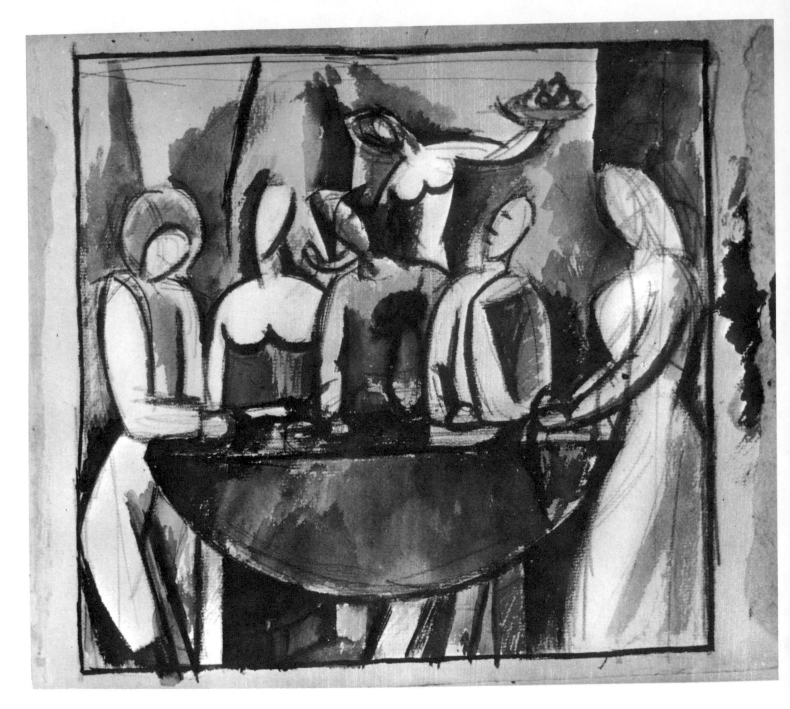

Meal. Graphite and watercolor, 9½ x 10⅞ inches. 1908

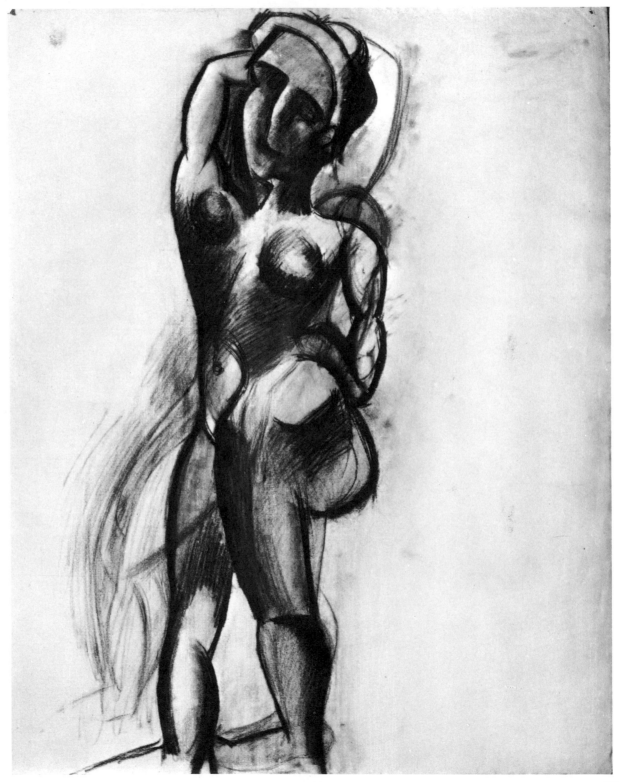

Standing Nude Woman
Charcoal
and conté crayon,
24⅝ x 19 inches
1909

Head of a Woman
Conté crayon,
24¾ x 19 inches
1909

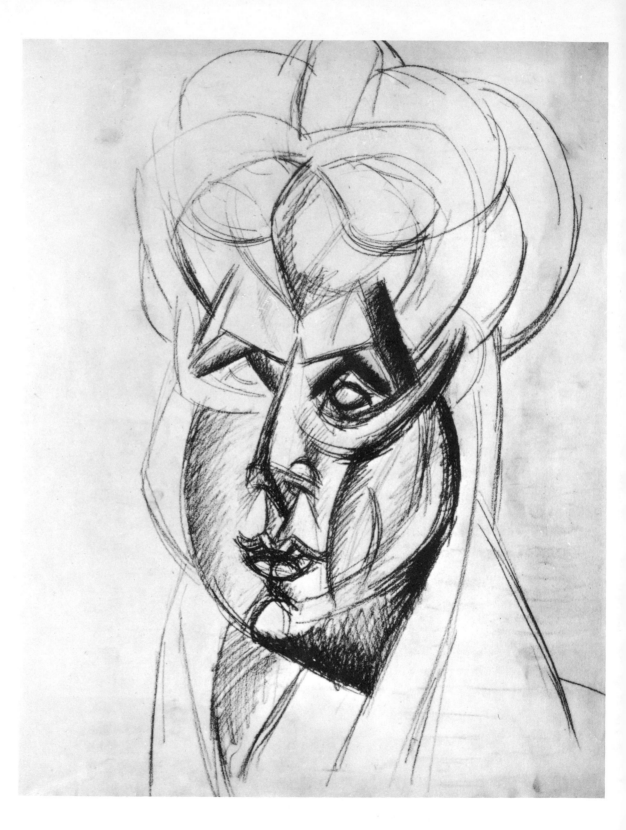

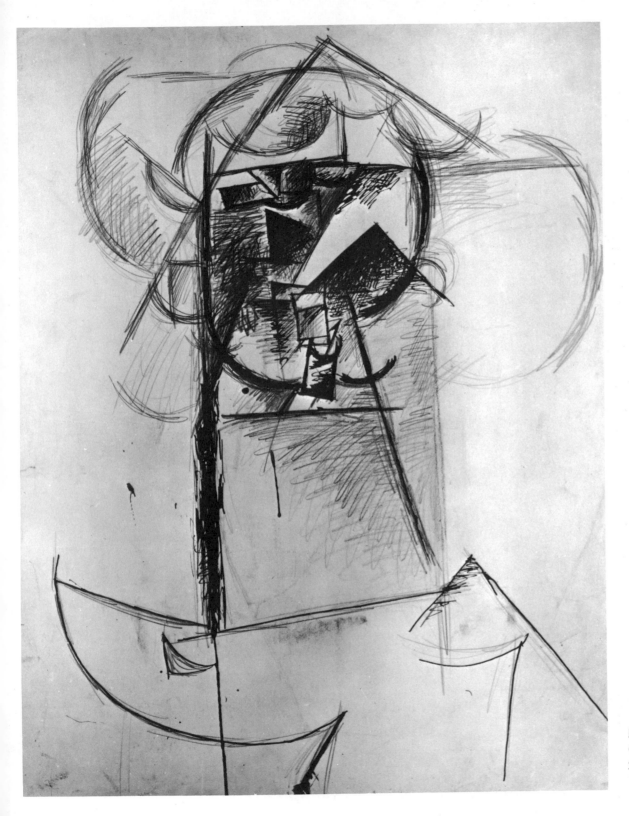

Head
*Graphite and India ink,
25⅜ x 19½ inches
1910*

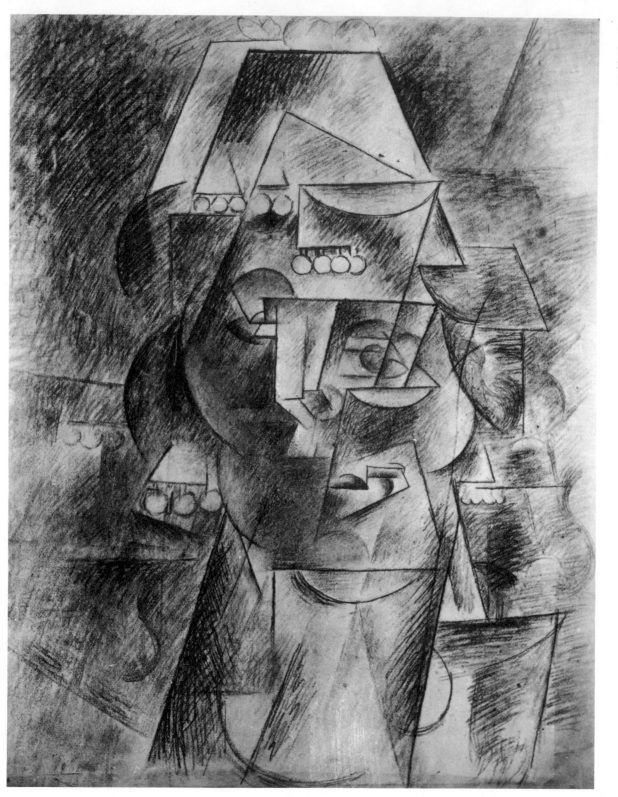

The Algerian Woman
*Charcoal and conté crayon,
25⅜ x 19¼ inches
1910*

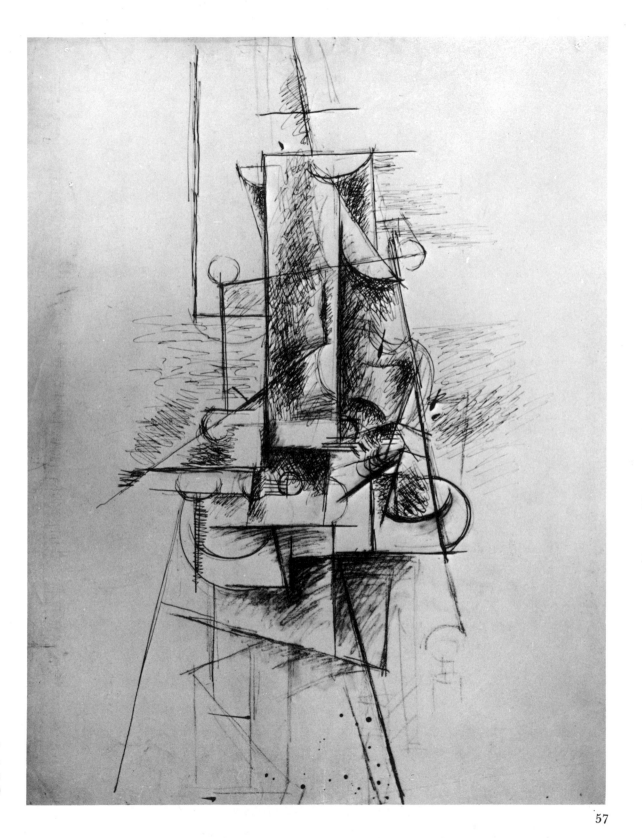

Still Life
Conté crayon and ink,
25¼ x 19⅜ inches
1910

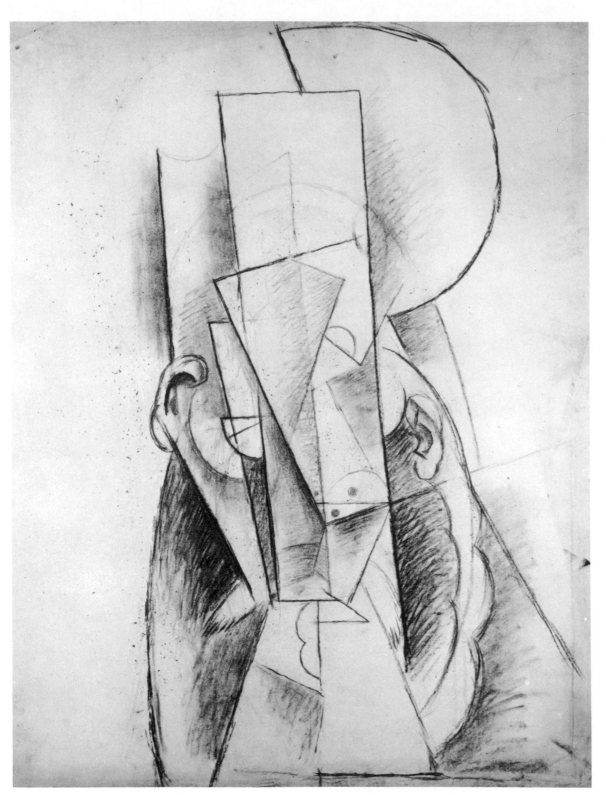

Head of a Man
Charcoal,
26⅛ x 20 inches
1911

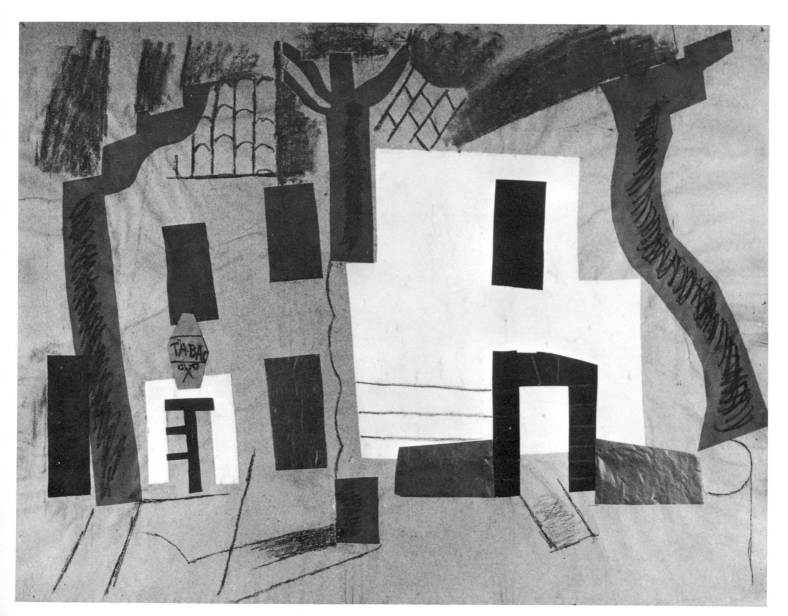

Céret. Pasted paper, charcoal, and pastel, 24¾ x 18⅞ inches. 1913

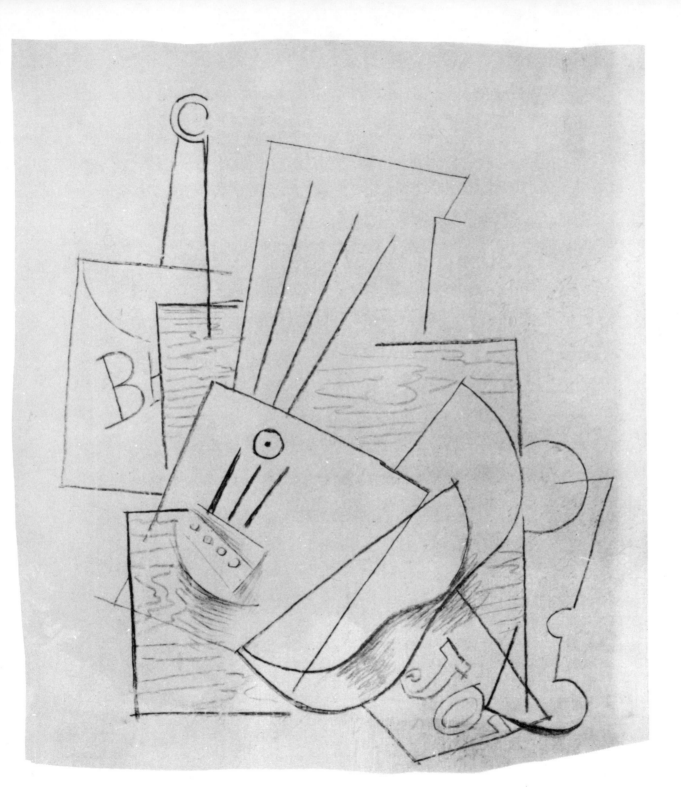

Still Life. Pencil, 18⅝ x 15⅞ inches. 1913 or 1914

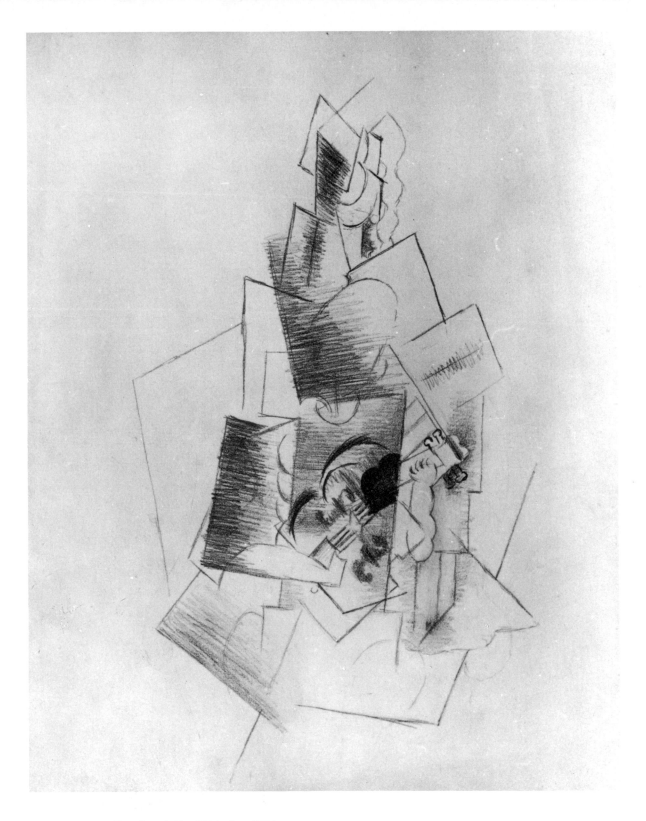

Female Musician. *Graphite, 12⅝ x 9⅝ inches. 1914*

Smoker with
His Elbow on a Table.
Pencil,
12¾ x 9⅝ inches
1914

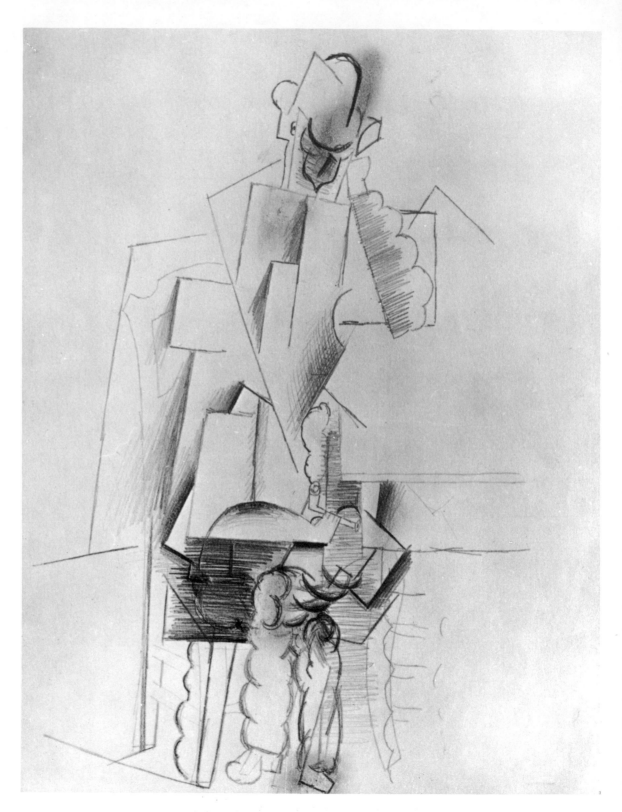

Three Still Lifes. *Ink, 14⅞ x 19½ inches. 1914*

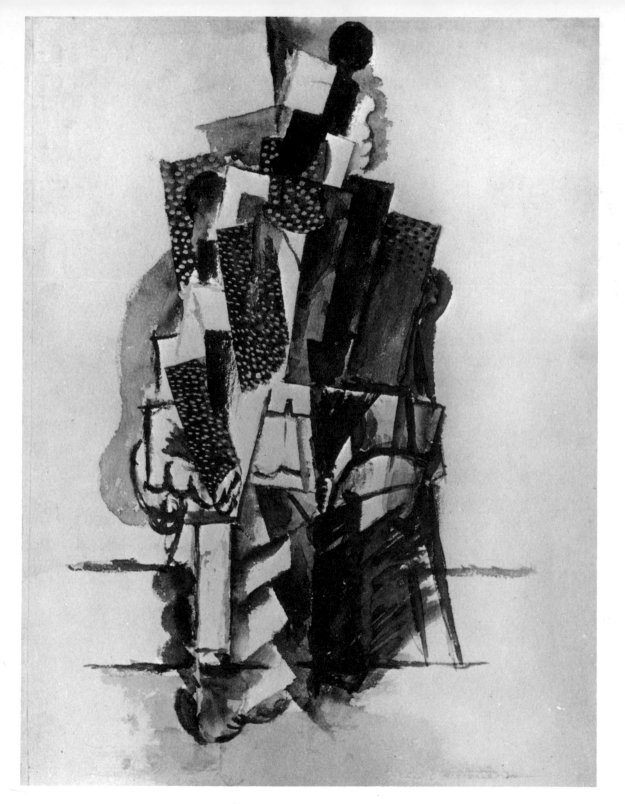

Seated Person. Watercolor and gouache, 13⅜ x 9¾ inches. 1914 or 1915

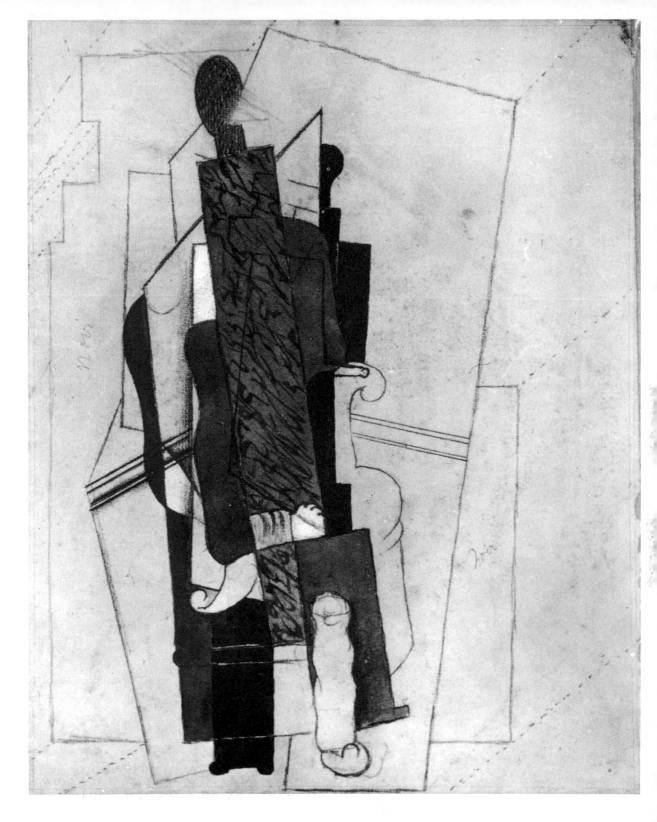

Seated Man. Pencil and watercolor, 12⅜ x 9⅝ inches. 1915 or 1916

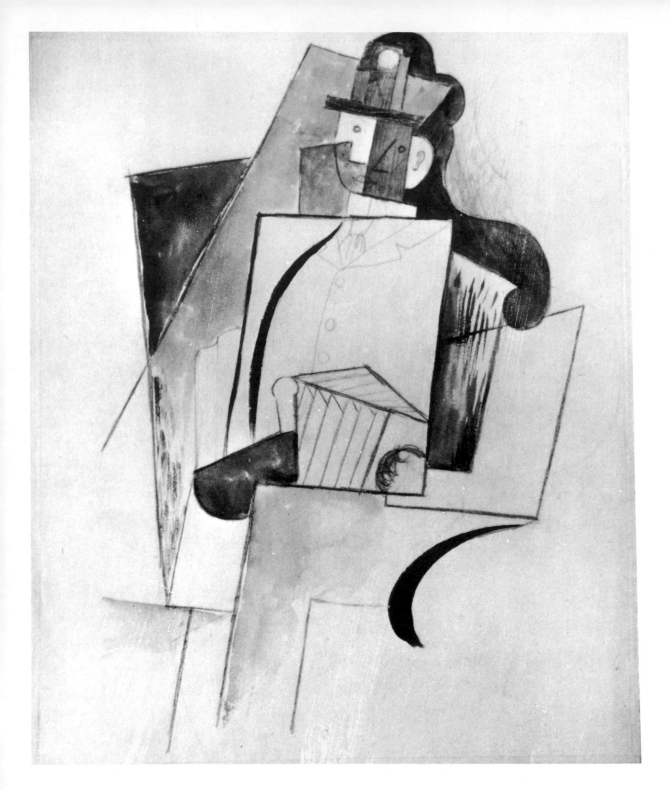

Seated Man. Pencil and watercolor, 11 x 8⅞ inches. 1916

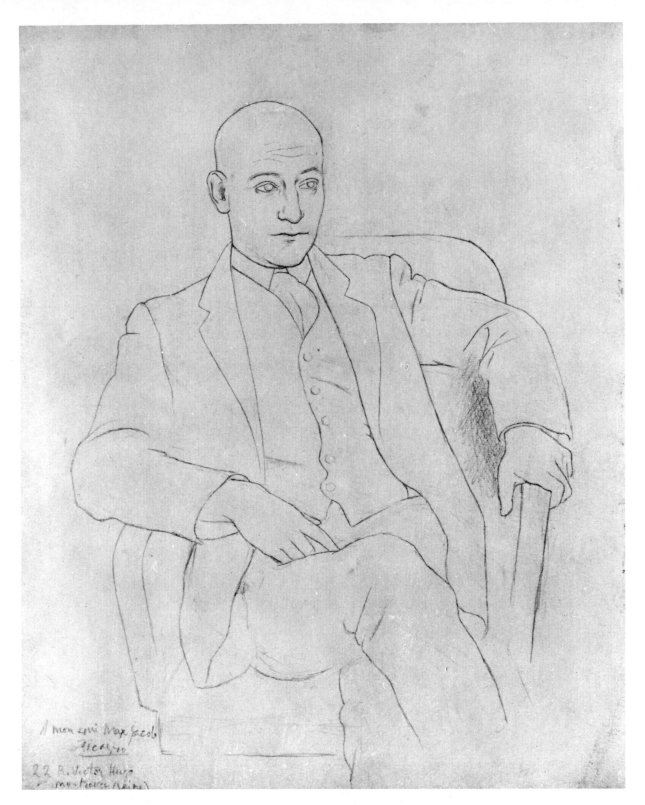

Portrait of Max Jacob. *Graphite, 12⅞ x 10 inches. 1917*

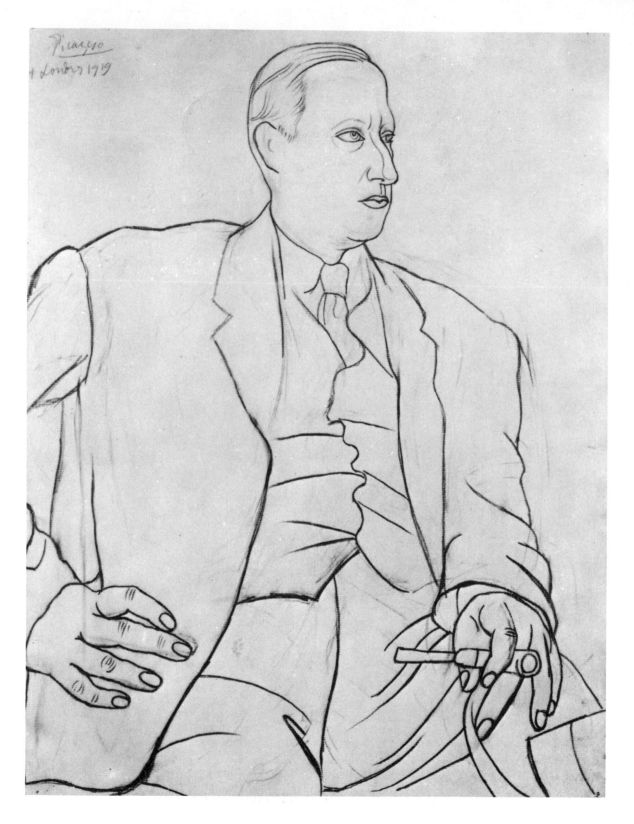

Portrait of Derain
Graphite,
15¾ x 12⅛ inches
1919

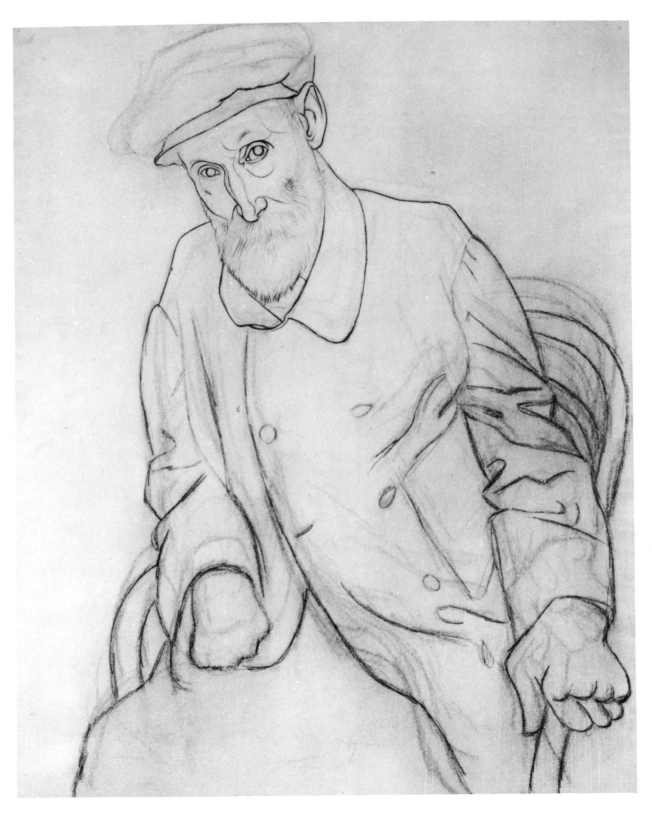

Portrait of Renoir
Graphite and charcoal,
24⅛ x 19⅜ inches
1919

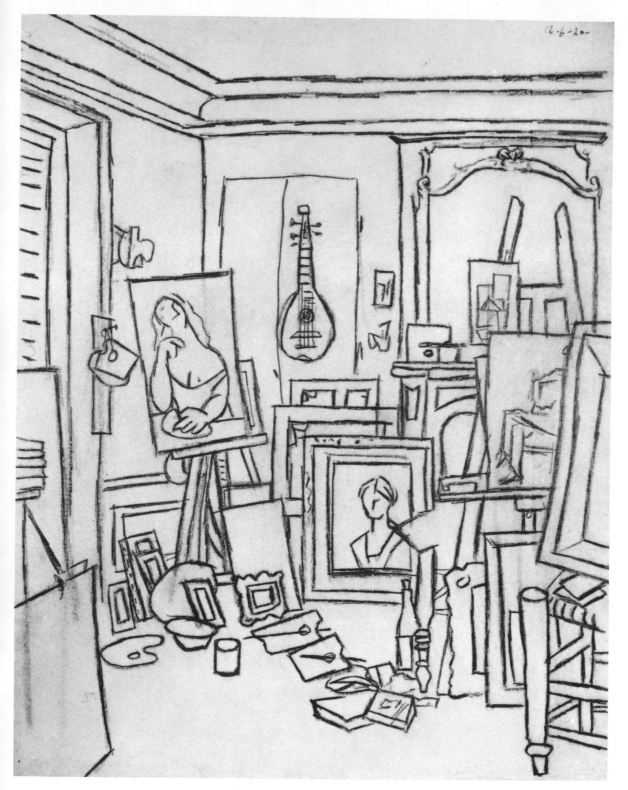

12-6-20

The Artist's Studio,
rue la Boétie
Pencil,
24¾ x 18⅞ inches
1920

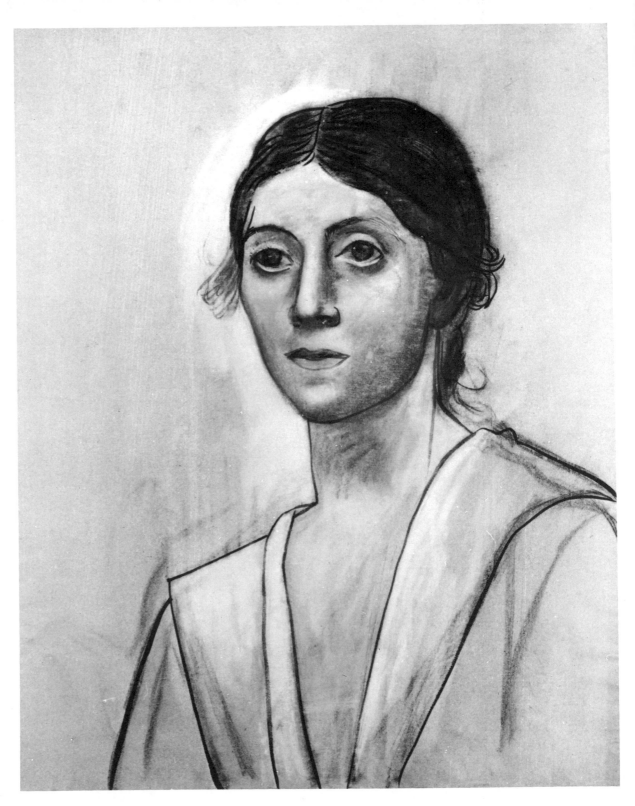

Portrait of Olga
*Charcoal,
ink, and pastel,*
24¾ x 19 inches
1920

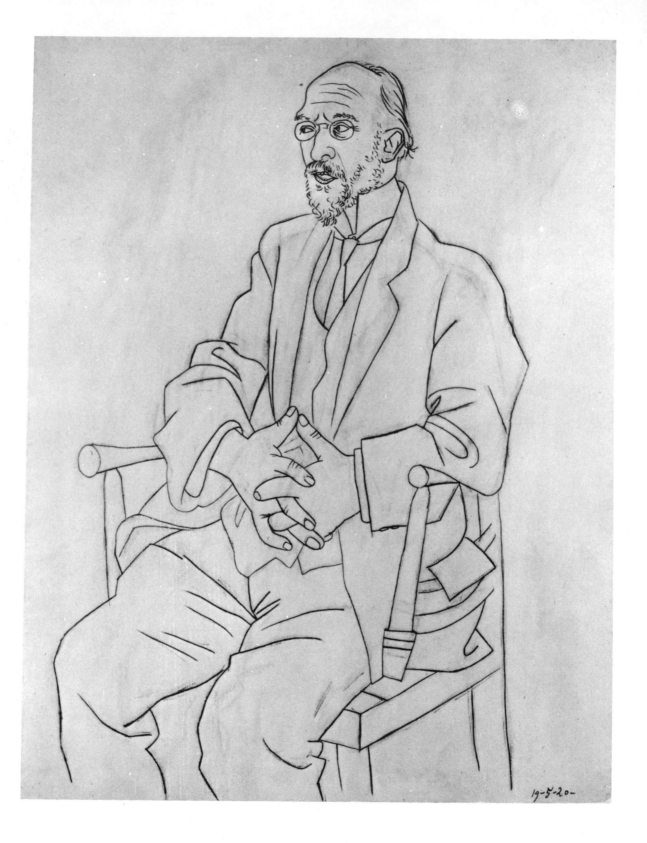

Portrait of Erik Satie
Graphite,
24½ x 19 inches
1920

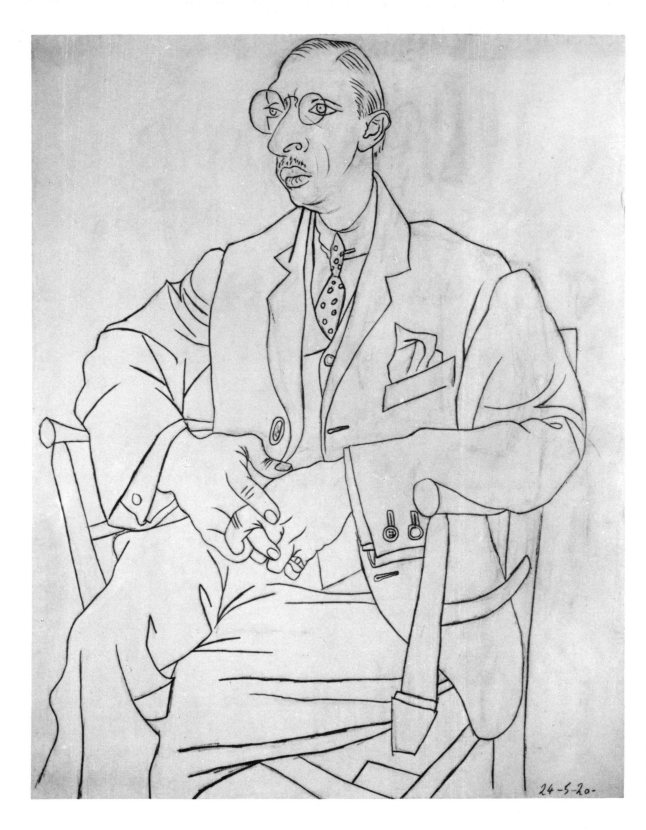

24-5-20.

Portrait of Igor Stravinsky
Graphite,
24½ x 19⅛ inches
1920

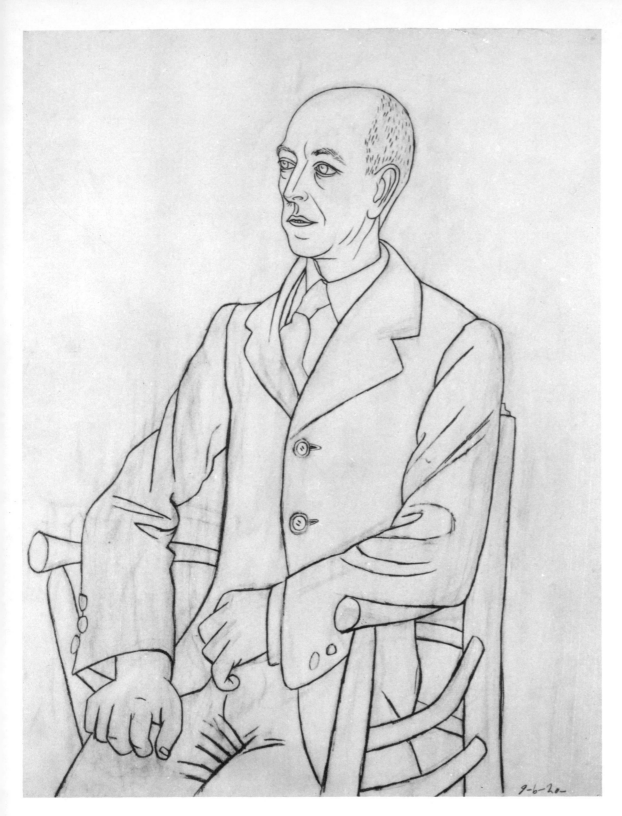

Portrait of
Manuel de Falla
Graphite,
24⅝ x 18⅞ inches
1920

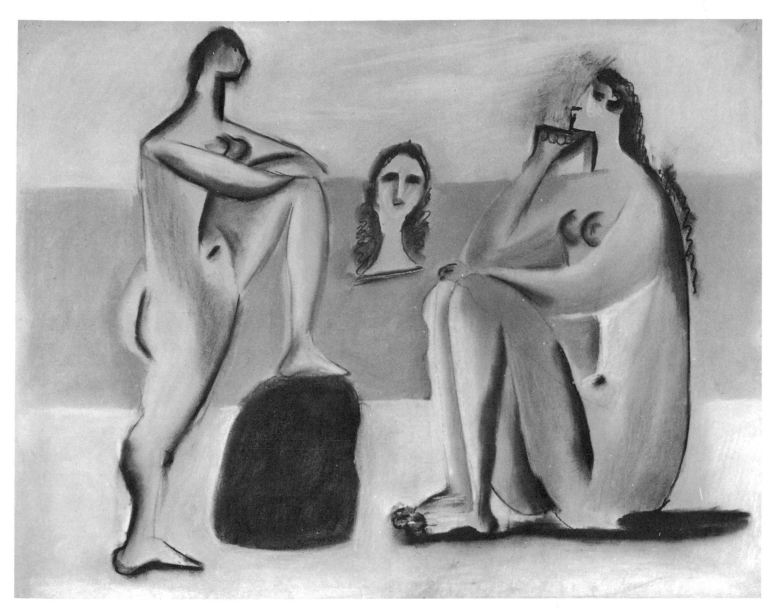

Three Bathers. *Pastel, 19⅝ x 25⅝ inches. 1920*

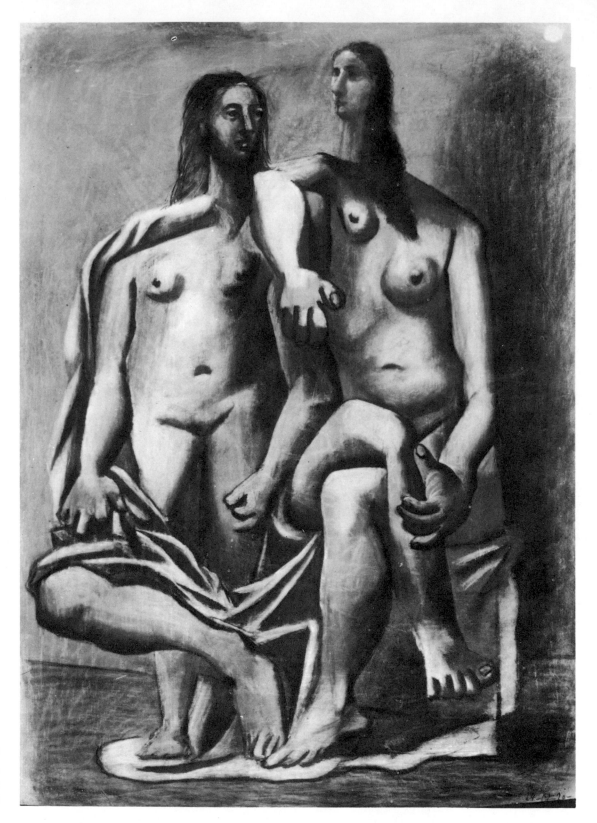

Two Nudes
Charcoal and pastel,
42½ x 29⅞ inches
1920

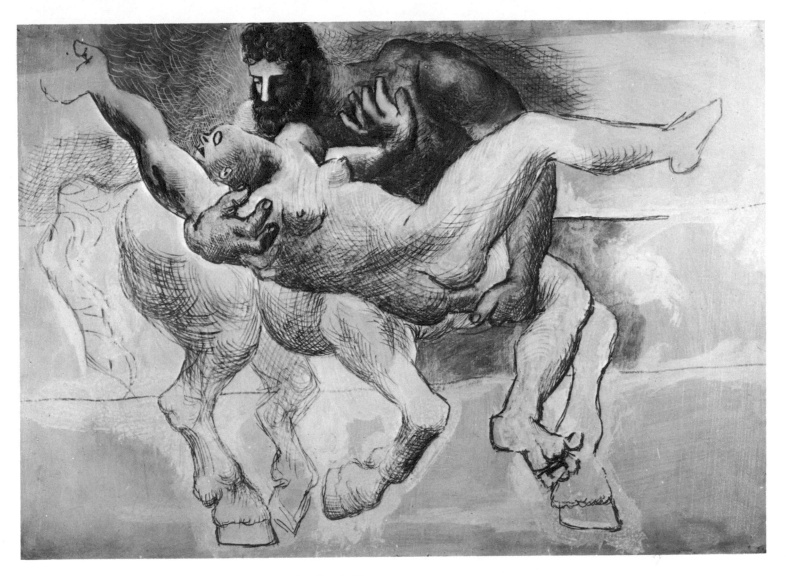

The Abduction. *Pencil, gouache, and pastel, 29⅛ x 41⅜ inches. 1920*

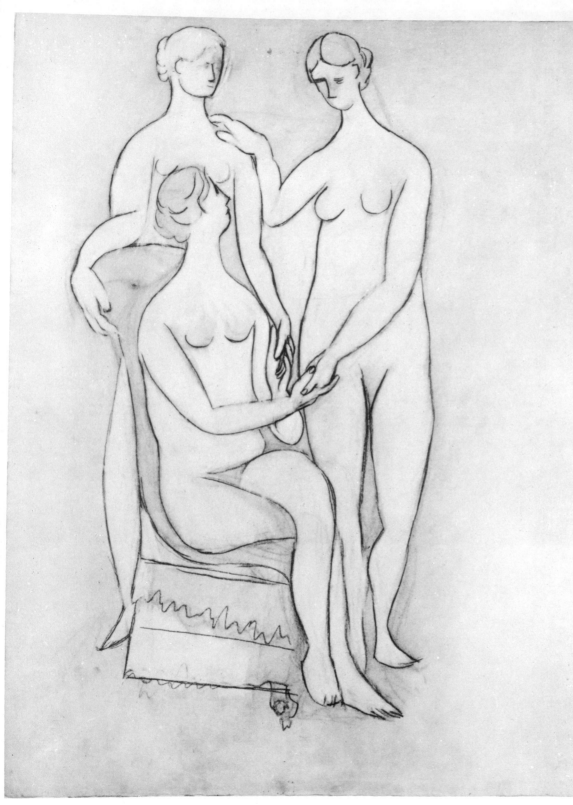

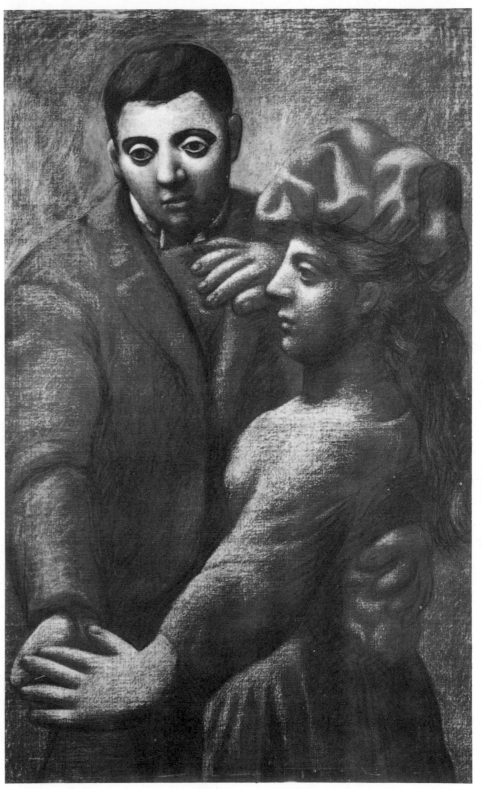

The Dancers
Pastel on canvas,
55⅛ x 33⅝ inches
1920 or 1921

Paulo. Charcoal and sanguine, 29½ x 42⅛ inches. 1921

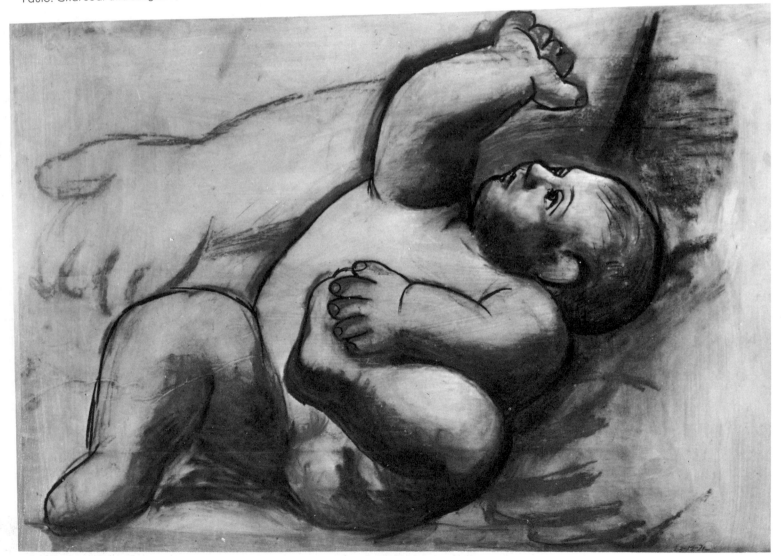

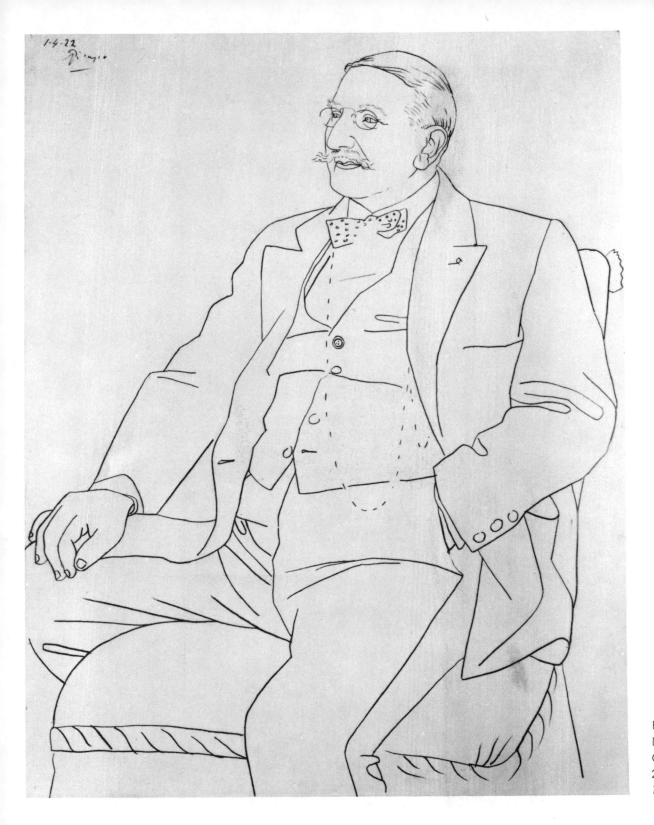

Portrait of
Leon Bakst
Graphite,
25¼ x 19⅜ inches
1922

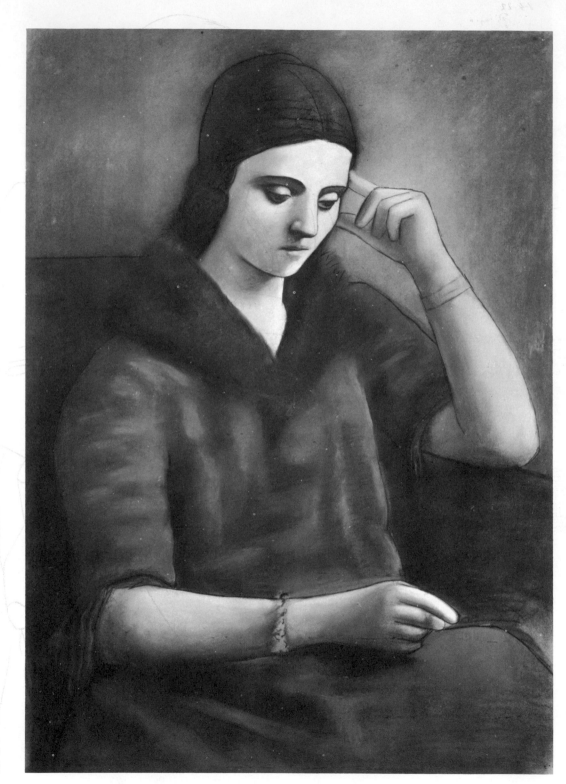

Portrait of Olga
Pastel,
41⅜ x 29½ inches
1923

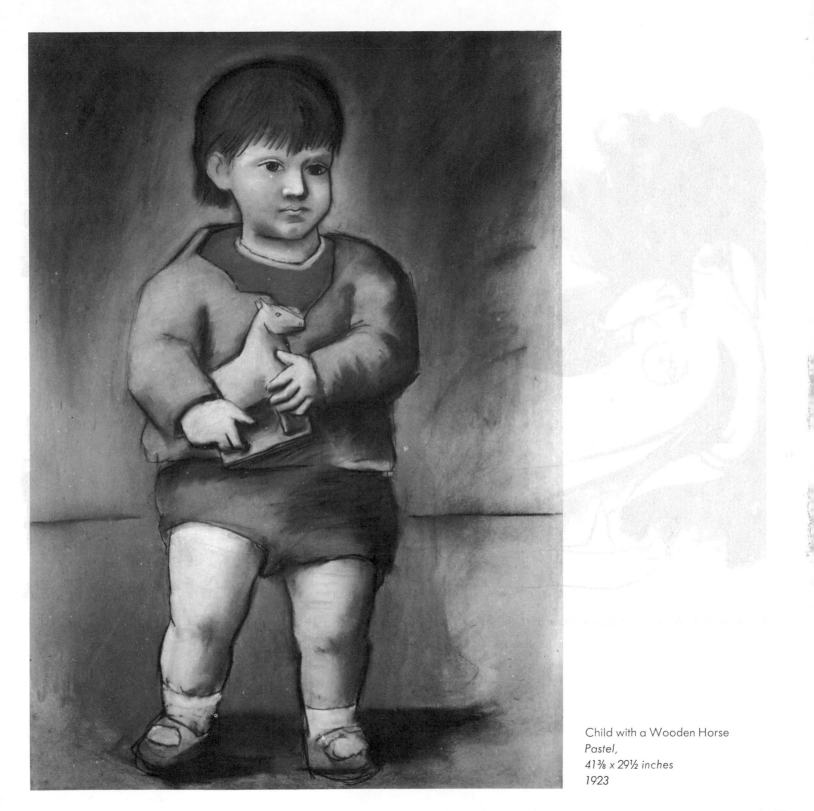

Child with a Wooden Horse
Pastel,
41⅜ x 29½ inches
1923

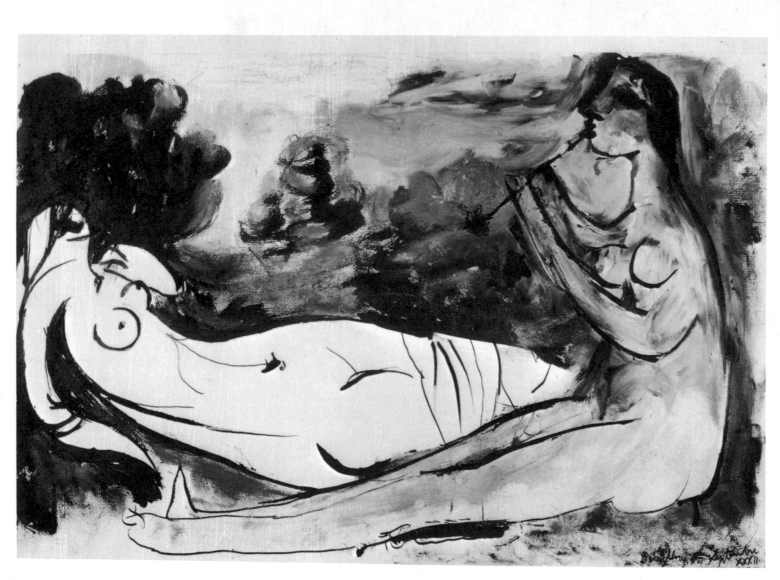

Reclining Nude Woman and Woman Playing a Flute. *India ink and oil, 13½ x 20⅛ inches. 1932*

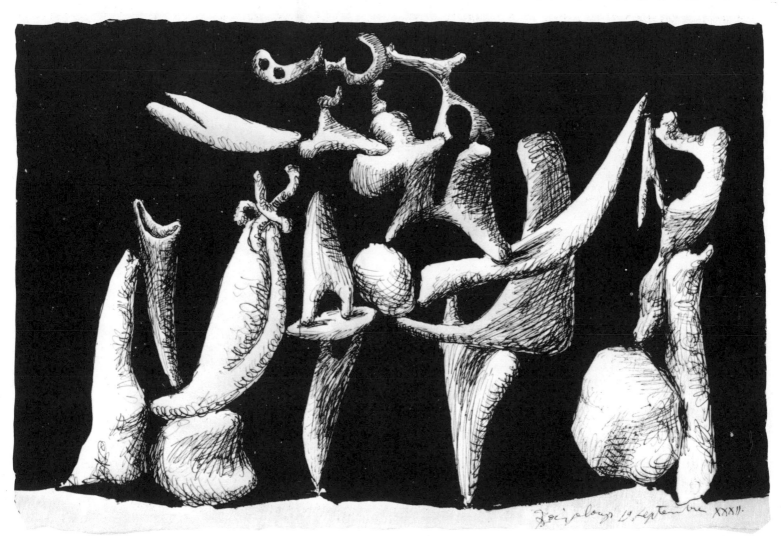

Crucifixion. *India ink,* 13⅝ x 20⅛ inches. 1932

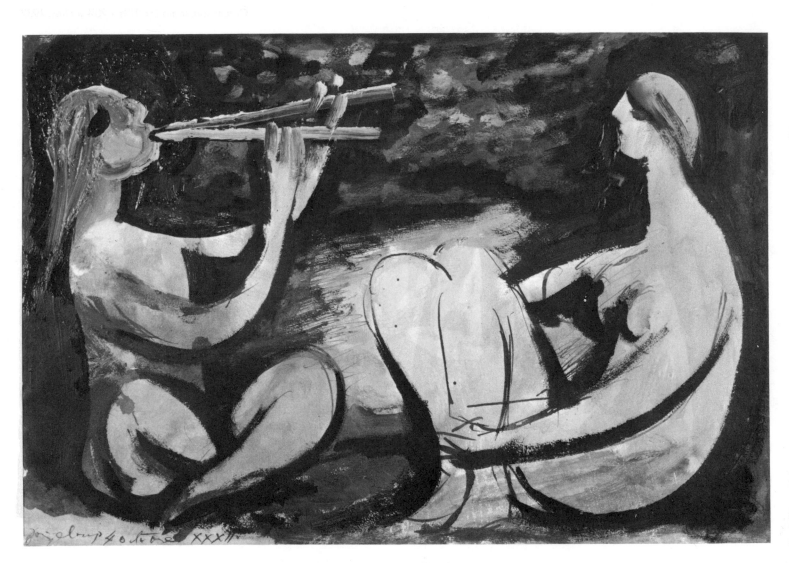

Woman Playing a Diaulos, and a Nude Woman. *Watercolor and oil, 13½ x 20¼ inches. 1932*

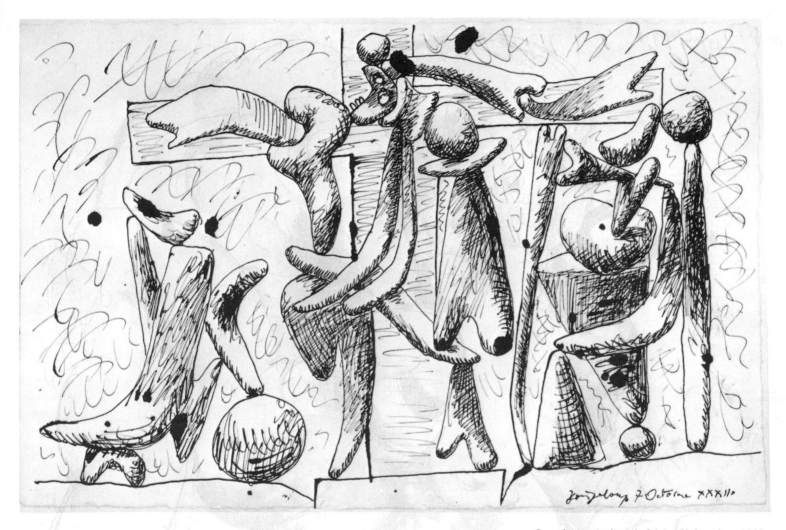

Crucifixion. *India ink, 34.4 x 51.3 inches. 1932*

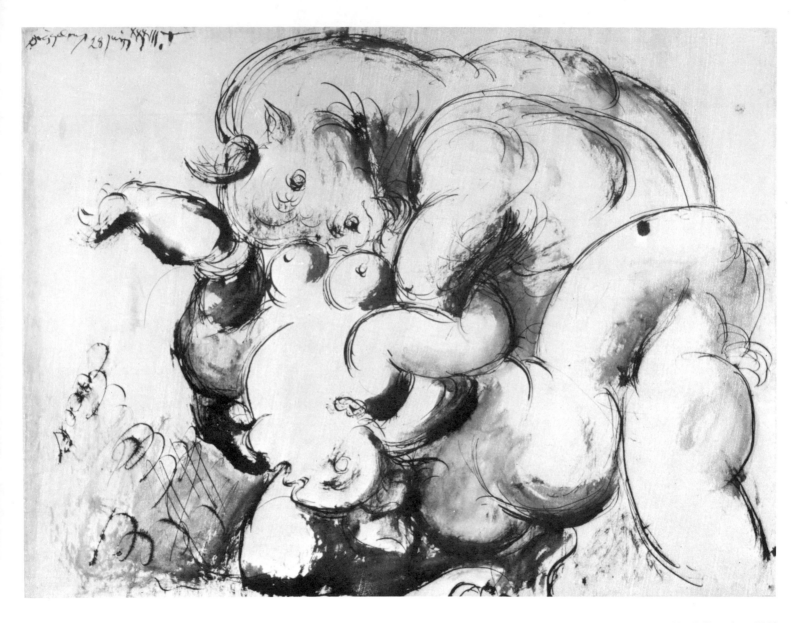

Minotaur. *India ink, 18⅝ x 24½ inches. 1933*

People. *Watercolor and India ink, 15¾ x 19⅞ inches. 1933*

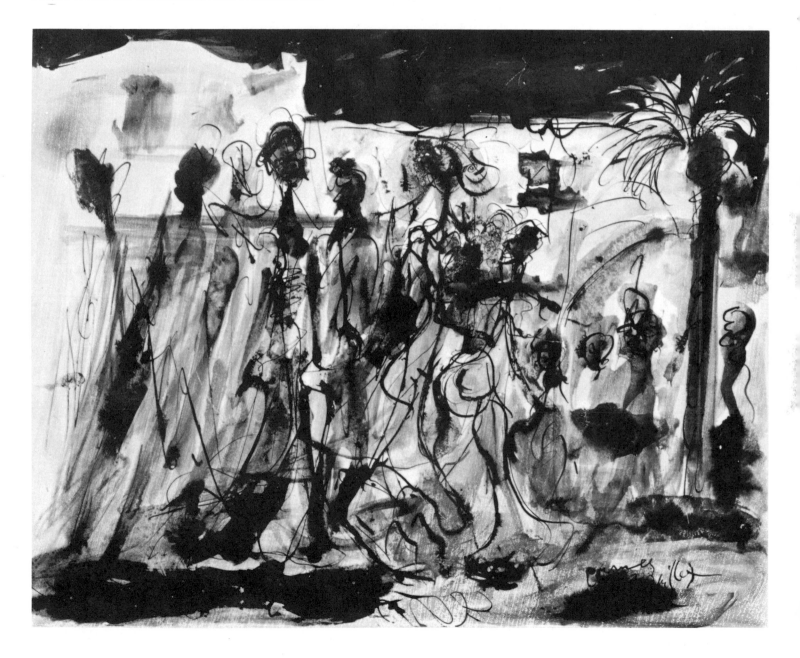

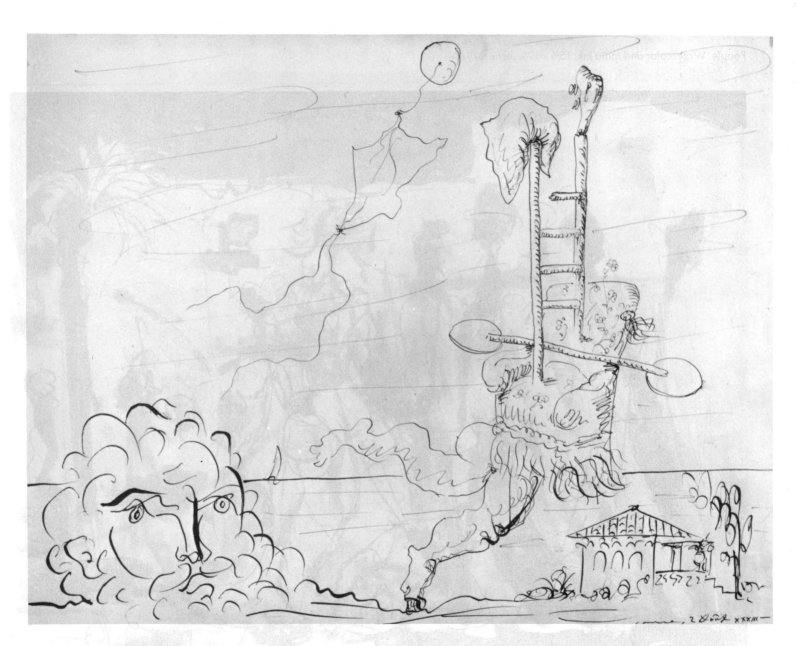

Surrealist Composition. *India ink, 15⅞ x 19⅞ inches. 1933*

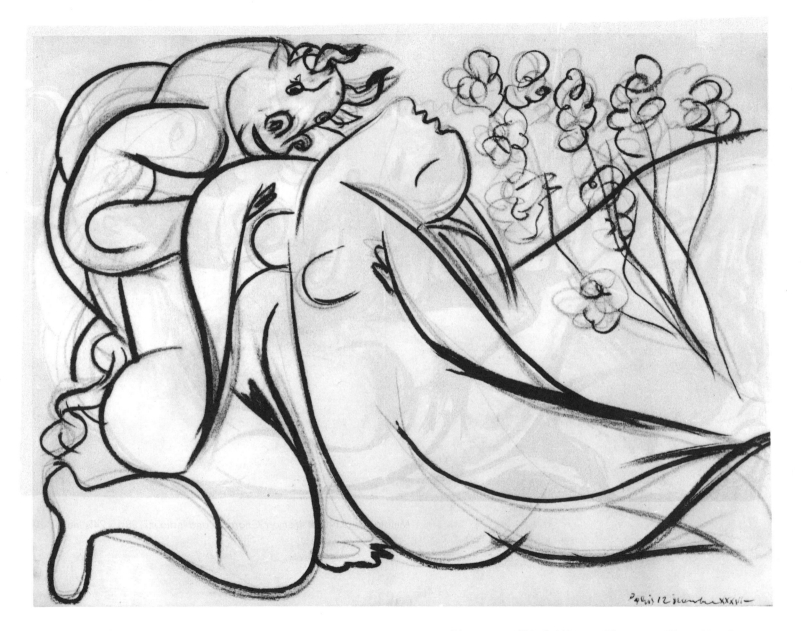

Minotaur and Nude Woman. *Charcoal, 18¾ x 16½ inches. 1933*

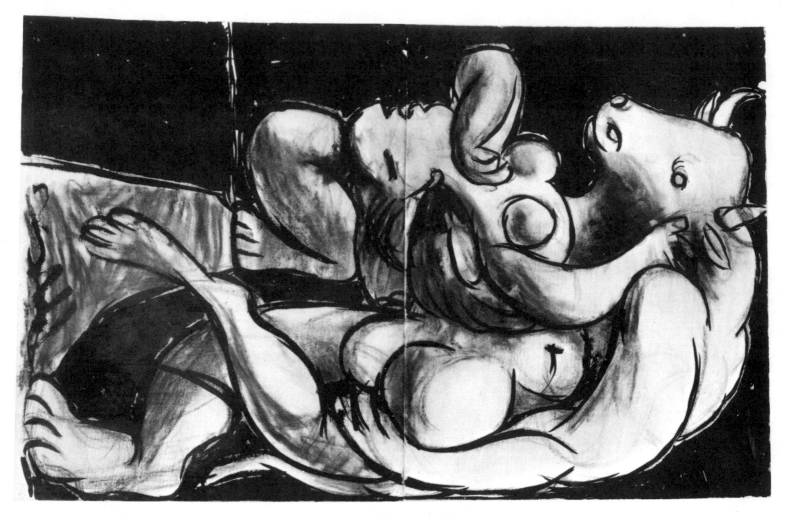

Minotaur and Nude Woman. *Charcoal and India ink, 38⅛ x 24⅛ inches. 1933*

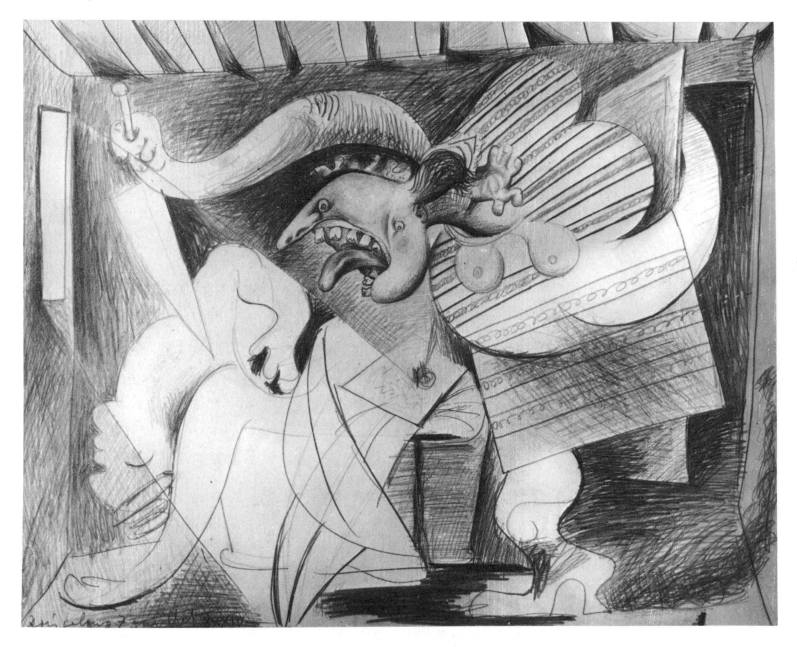

The Murder. *Graphite on cardboard, 15⅞ x 19⅞ inches. 1934*

Wounded Bull, Horse, and Nude Woman. *Charcoal and India ink, 13⅝ x 20¼ inches. 1934*

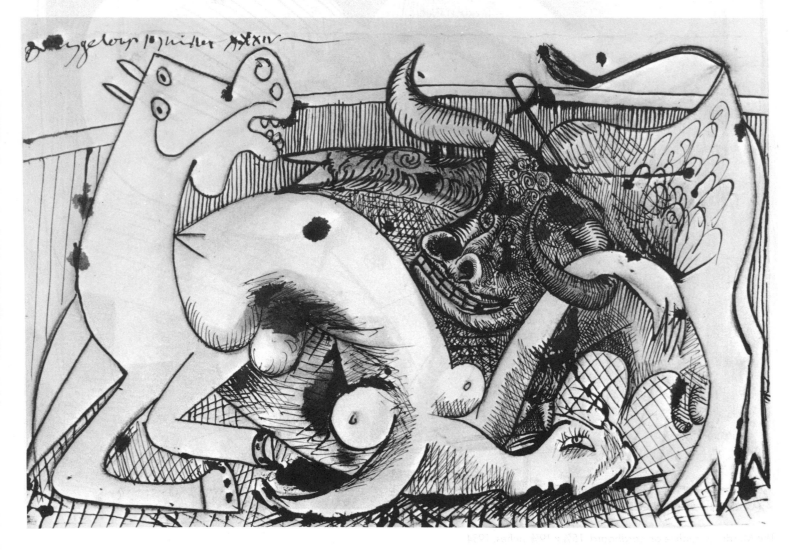

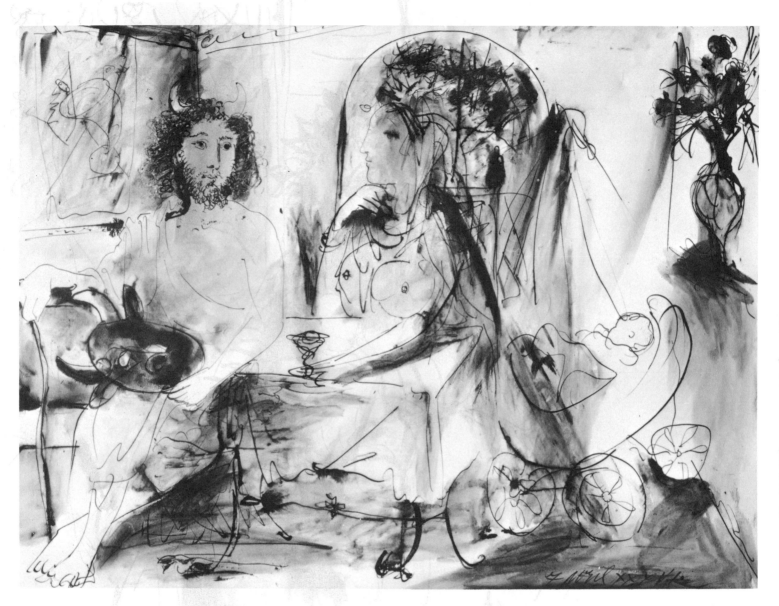

Young Faun, Woman, and Child. *India ink, 19¾ x 25¾ inches. 1936*

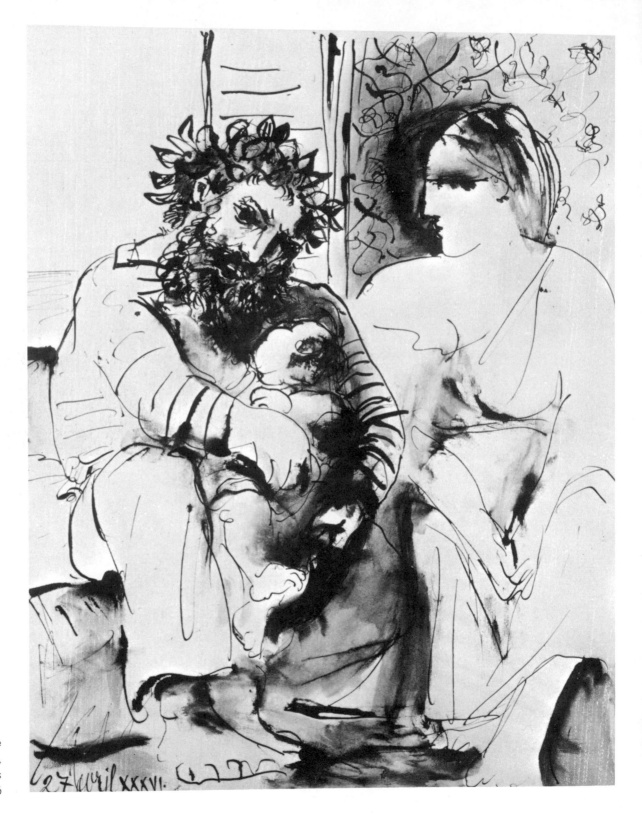

Family Scene
*India ink,
24⅝ x 18⅞ inches
1936*

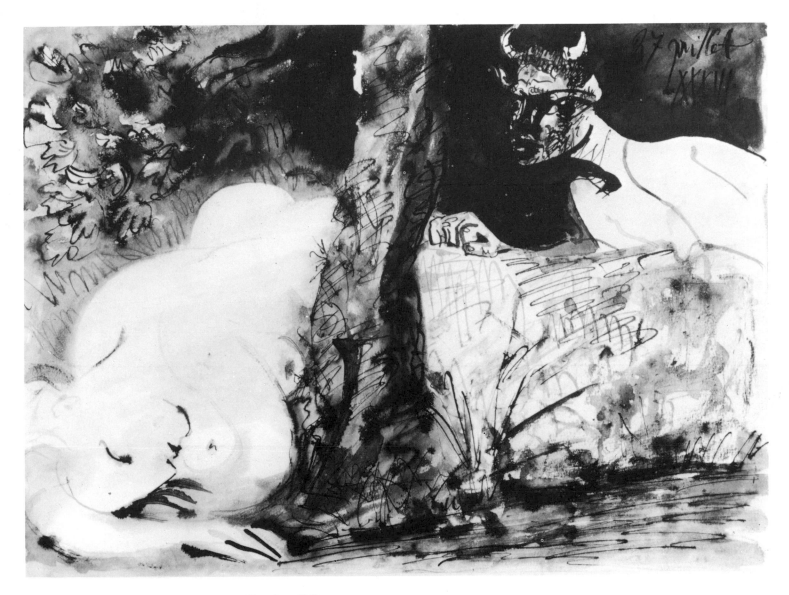

Faun and Nude Woman. *India ink, 14⅜ x 20⅛ inches. 1936*

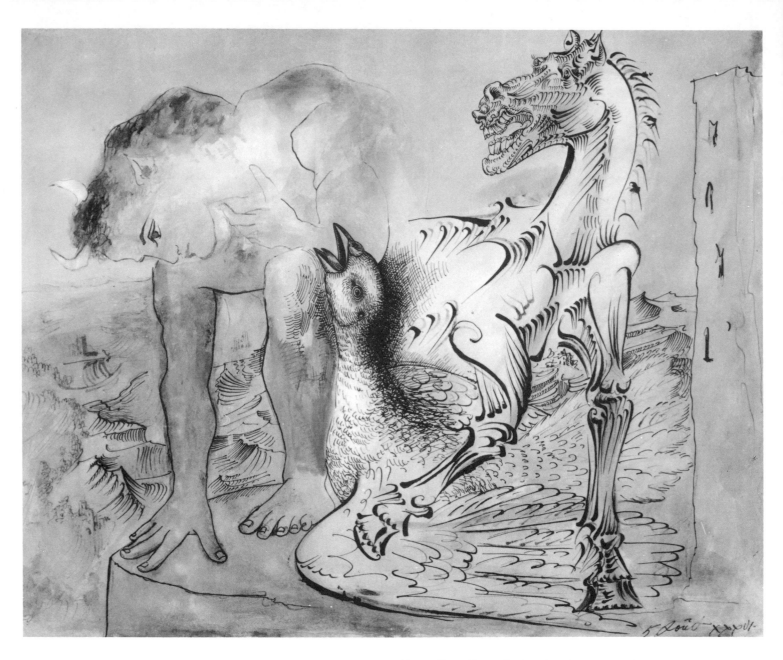

Young Faun, Horse, Bird. *India ink and gouache, 17⅜ x 21⅜ inches. 1936*

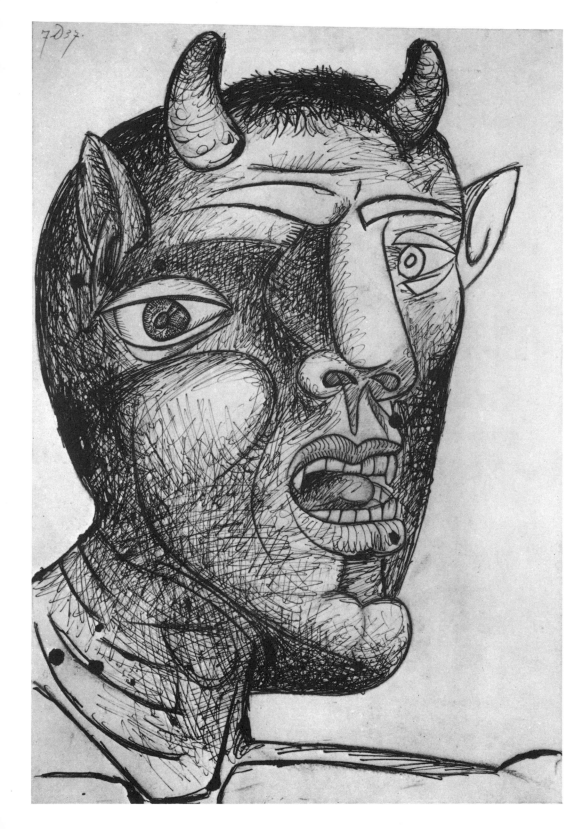

Head of a Satyr
India ink and pencil,
22½ x 15⅛ inches
1937

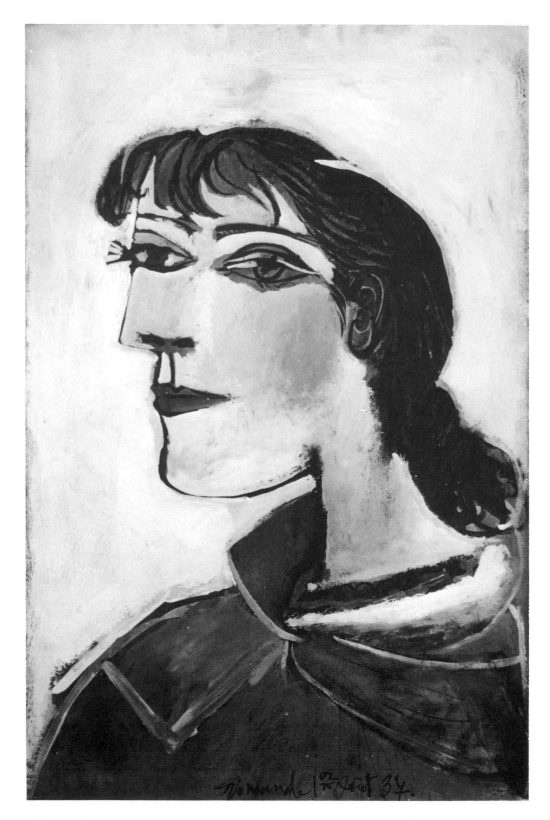

Head of a Woman
Gouache and India ink,
18 x 11½ inches
1937

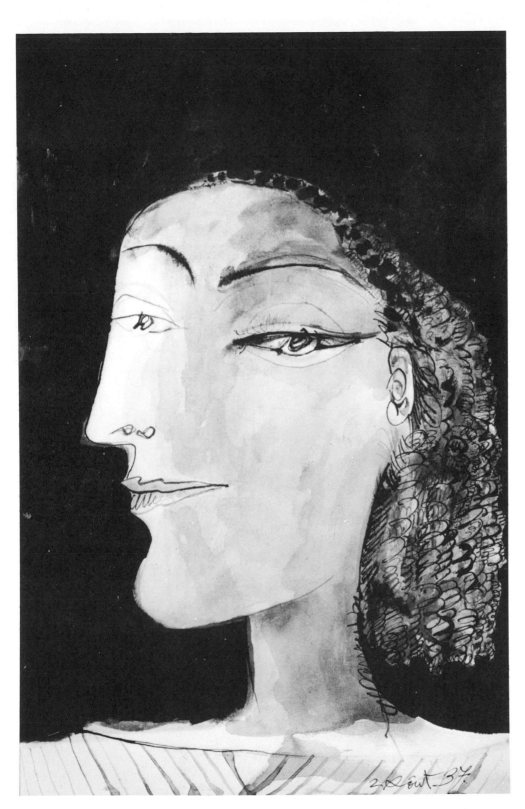

Head of a Woman
India ink and gouache,
18 x 11½ inches
1937

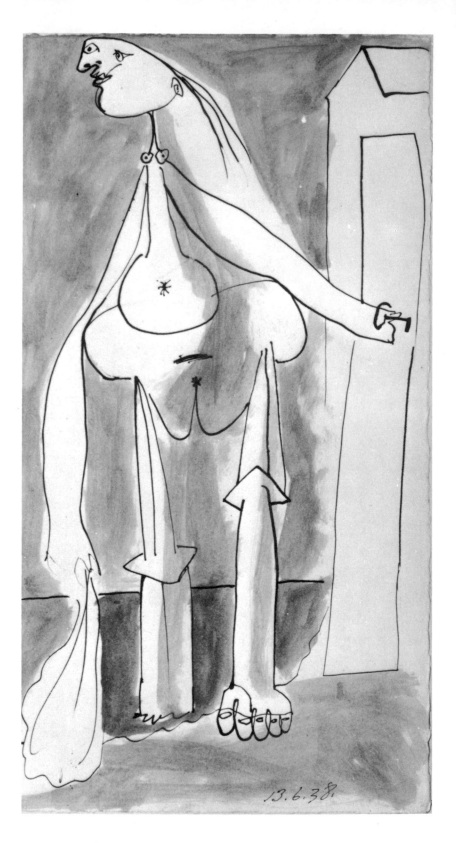

Bather
India ink and oil with thinner,
18 x 9⅝ inches
1938

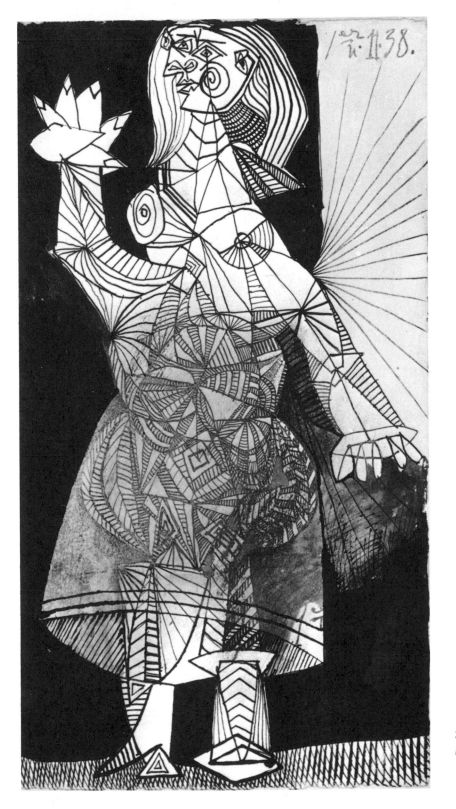

Standing Woman
India ink and gouache,
17⅞ x 9⅝ inches
1938

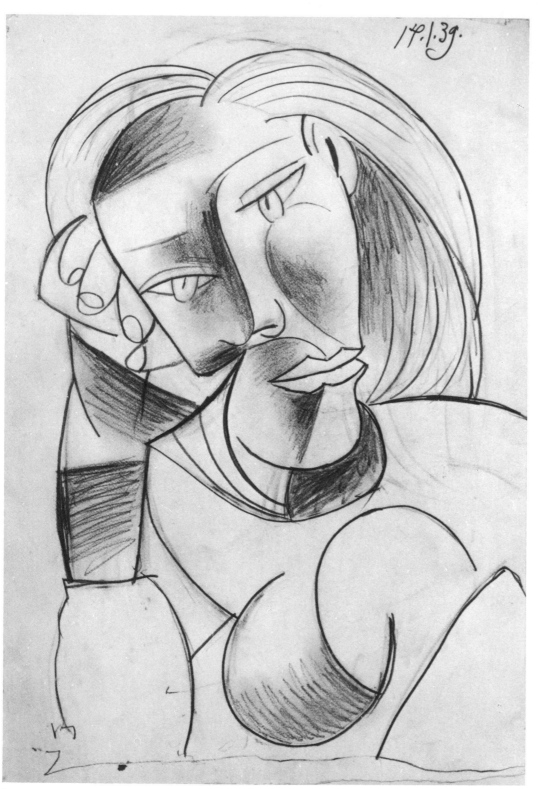

Head of a Woman
Pencil,
16⅞ x 11⅜ inches
1939

14.1.39.

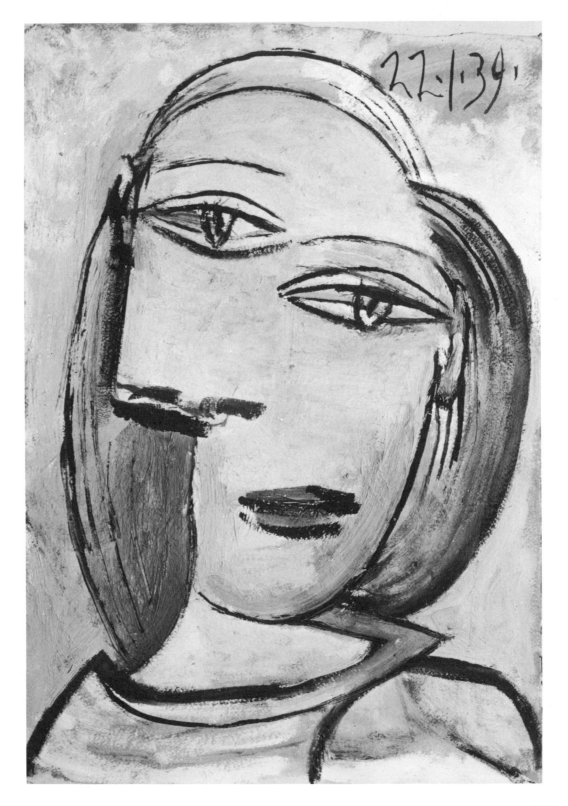

Head of a Woman
Oil,
16⅞ x 11⅜ inches
1939

Standing Nude with Peignoir
India ink,
25⅜ x 18 inches
1939

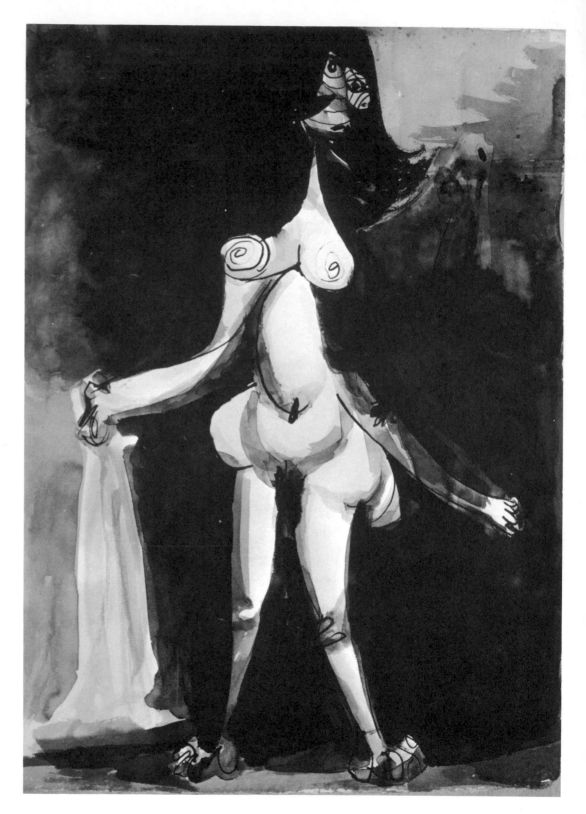

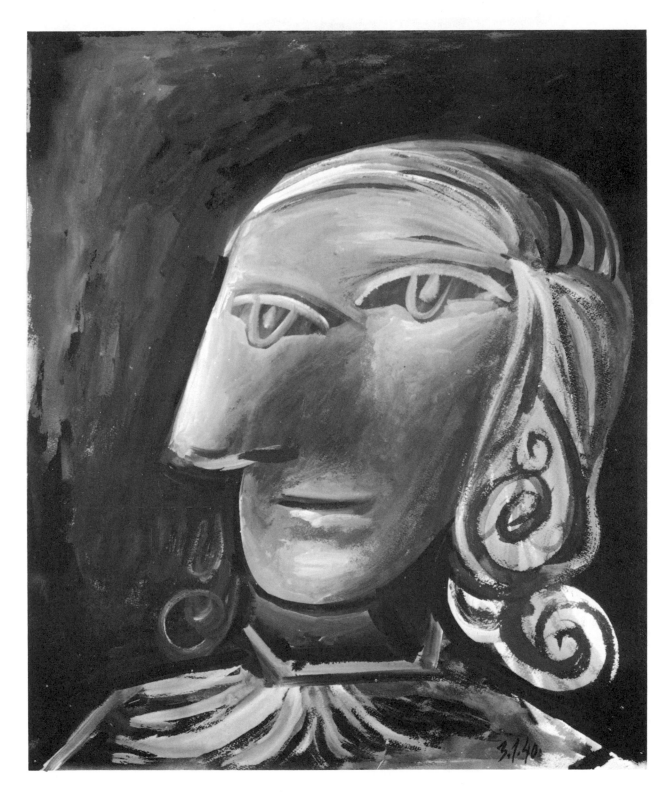

Head of a Woman. *Ink and gouache, 18⅛ x 15 inches. 1940*

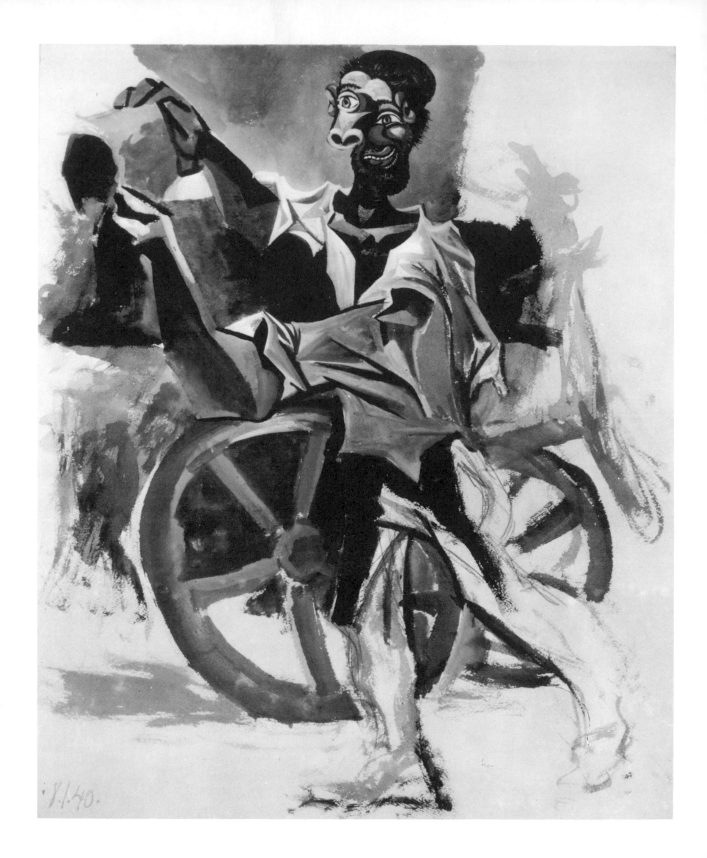

The Garbage Collector
Gouache,
18⅛ x 15 inches
1940

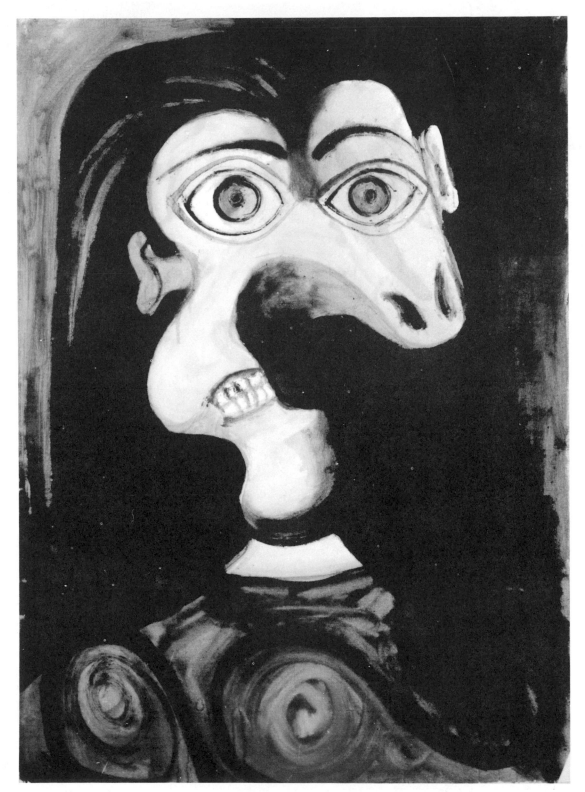

Bust of a Woman
Pencil, watercolor, and oil,
25 x 18⅛ inches
1940

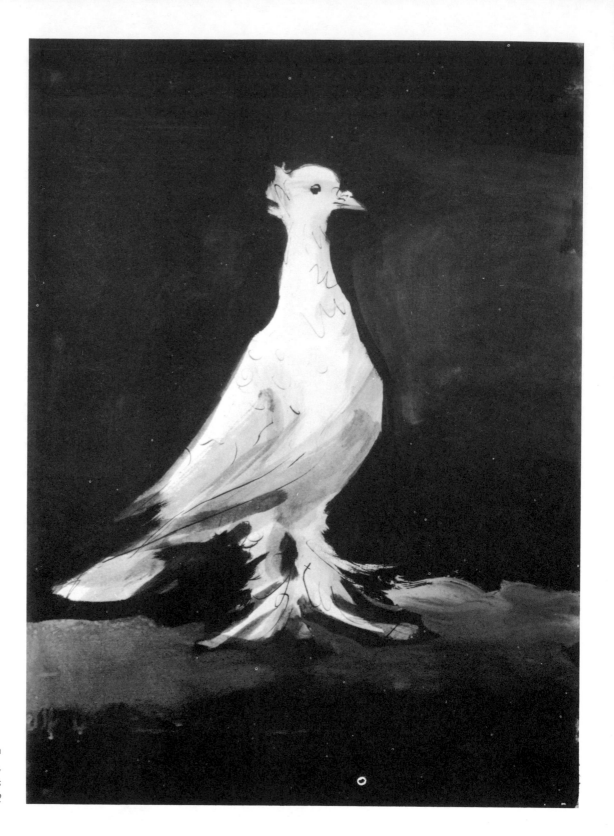

Pigeon
India ink and gouache,
25½ x 18⅛ inches
1942

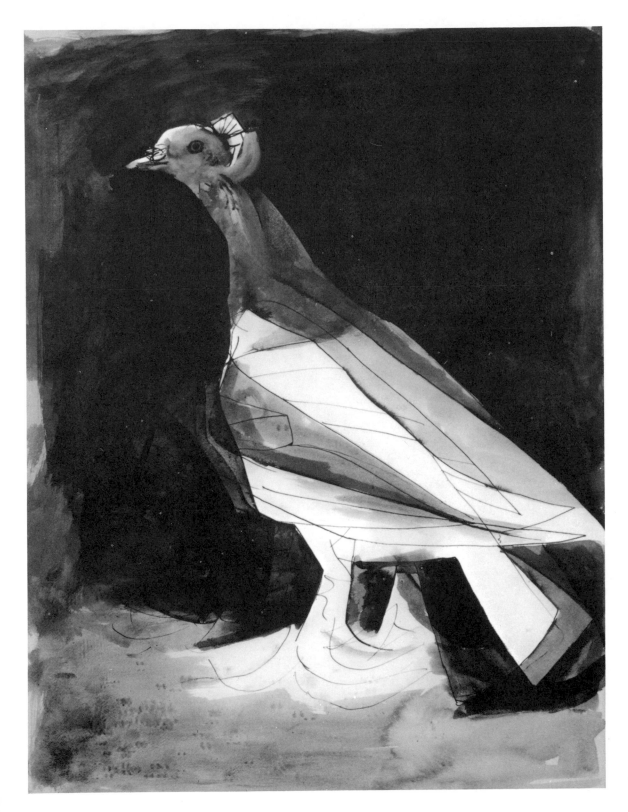

Dove
India ink and gouache,
25⅝ x 19⅝ inches
1942

111

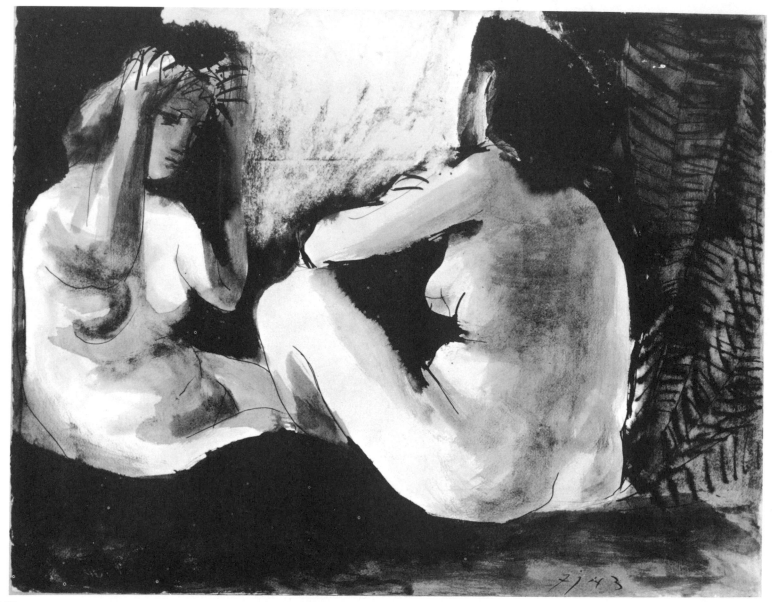

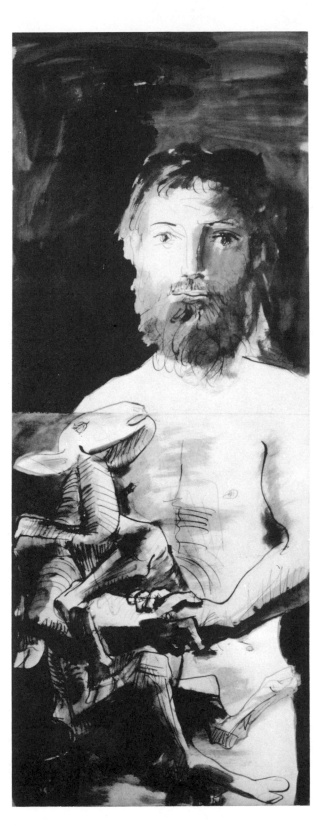

Study for
"The Man with a Sheep"
India ink,
51⅛ x 20 inches
1943

113

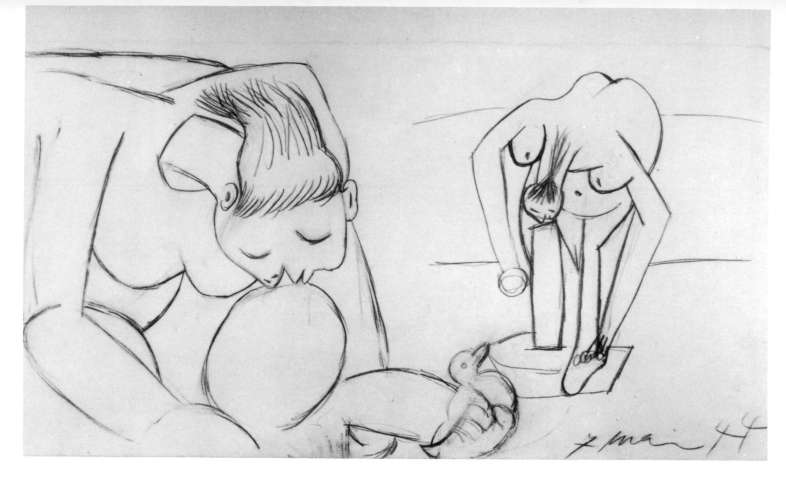

Studies. Pencil, 10½ x 20 inches. 1944

Bust of a Woman
*India ink, colored pencils,
and gouache on a lithograph,
25¾ x 19¾ inches
1949*

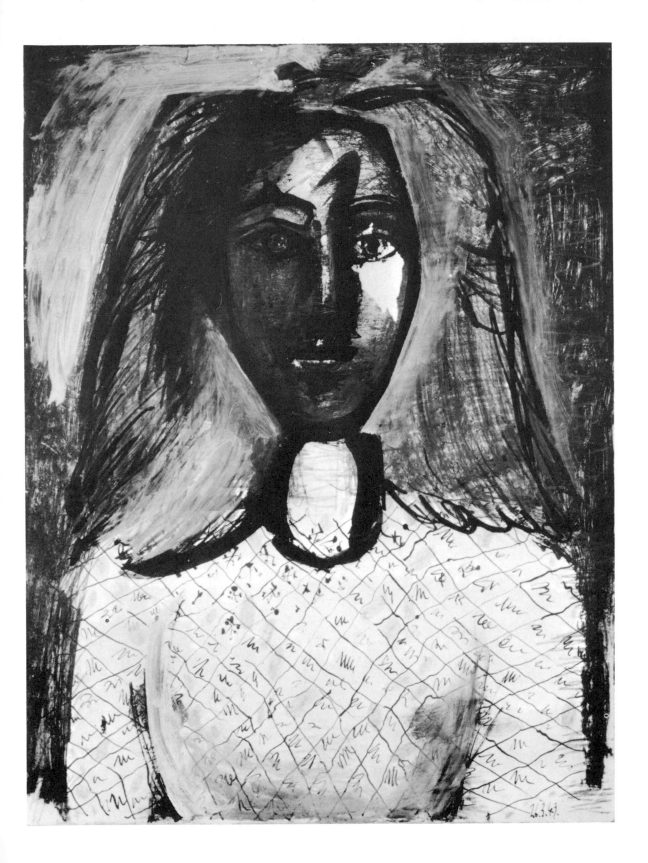

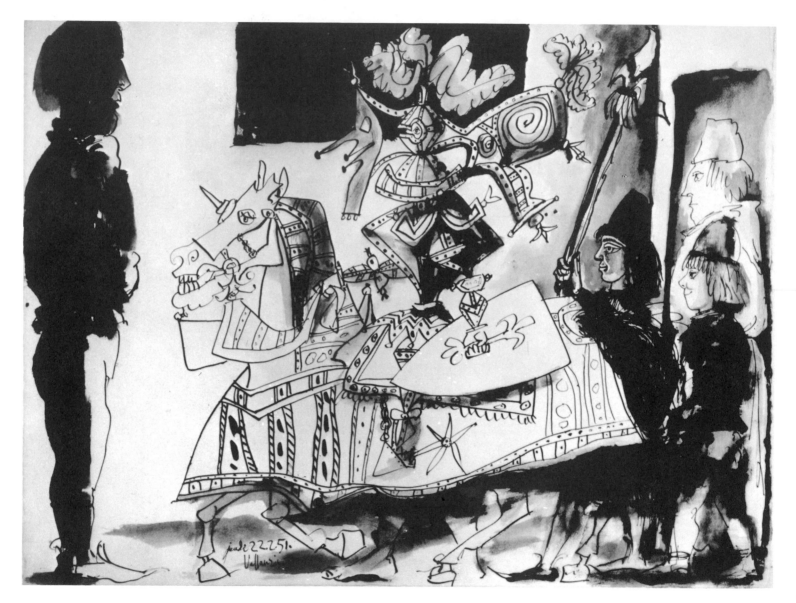

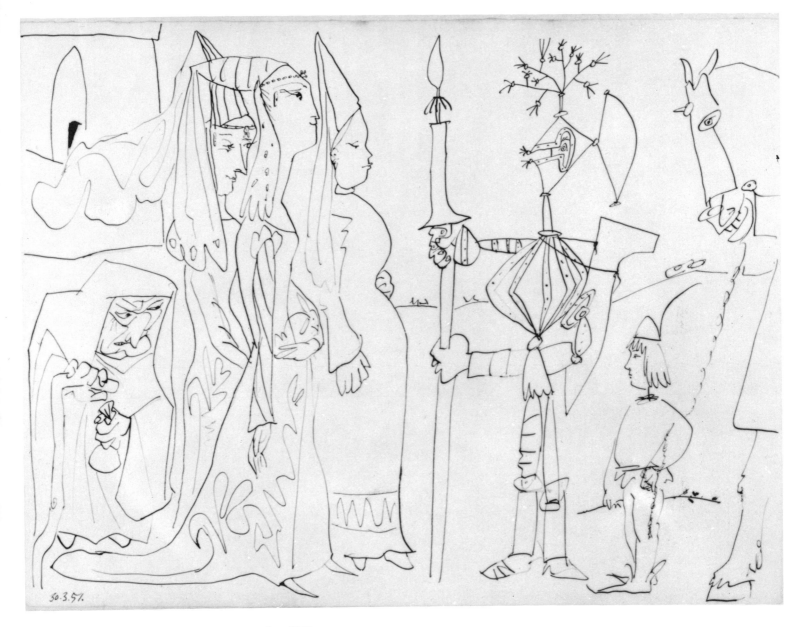

Knight, Women, and Page. *India ink, 20 x 26 inches. 1951*

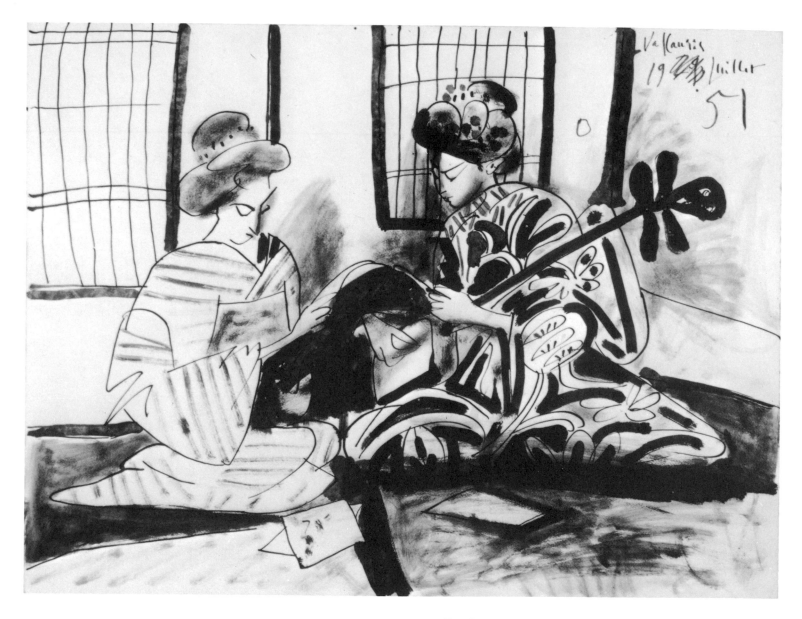

Two Japanese Ladies in an Interior. *India ink, 26¾ x 18 inches. 1951*

Head of a Goat. *India ink, 20 x 25⅞ inches. 1951*

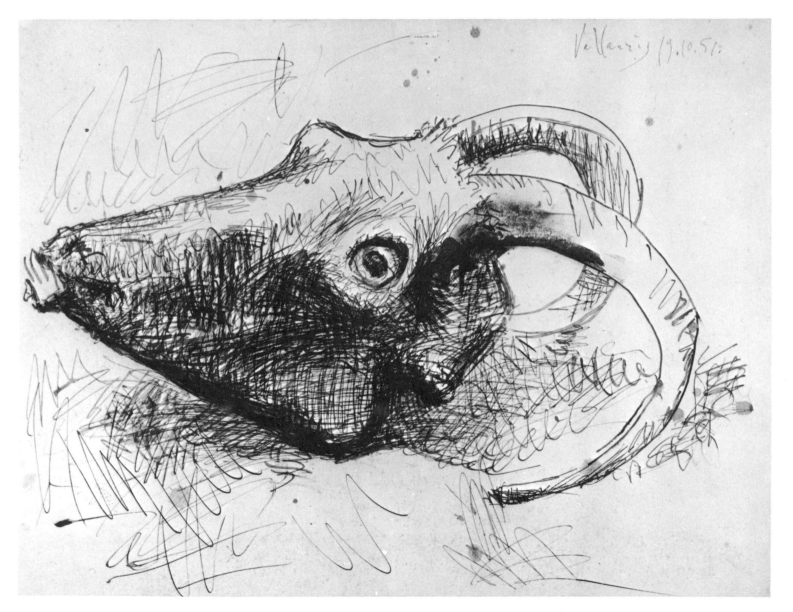

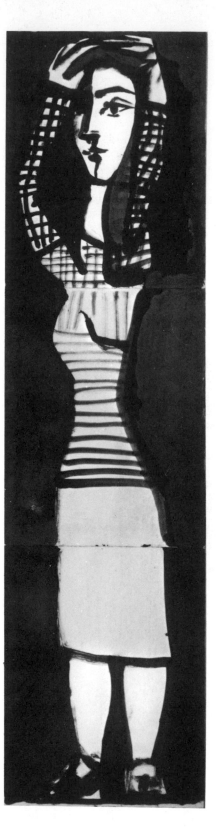

Standing Woman
Ink and oil,
77⅝ x 20 inches
1952

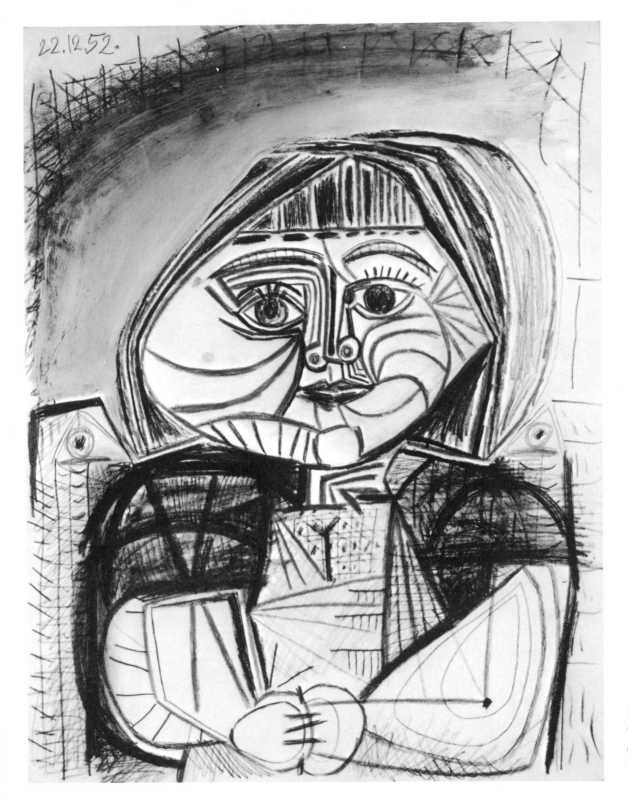

22.12.52.

Paloma
Colored pencils,
pencil, and oil,
25⅞ x 19⅞
1952

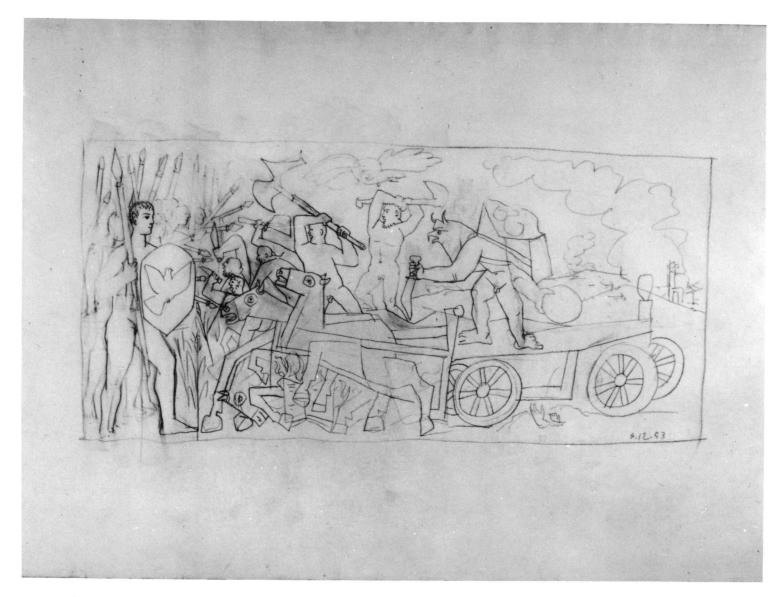

Sketch for "War." Graphite, 17⅝ x 26⅞ inches. 1953

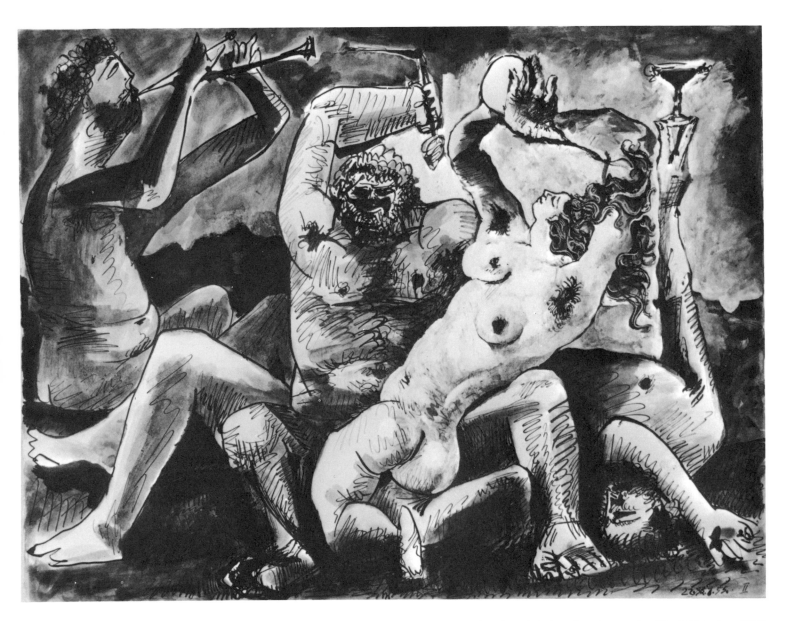

Bacchanal. *India ink and gouache, 20 x 25⅞ inches. 1955*

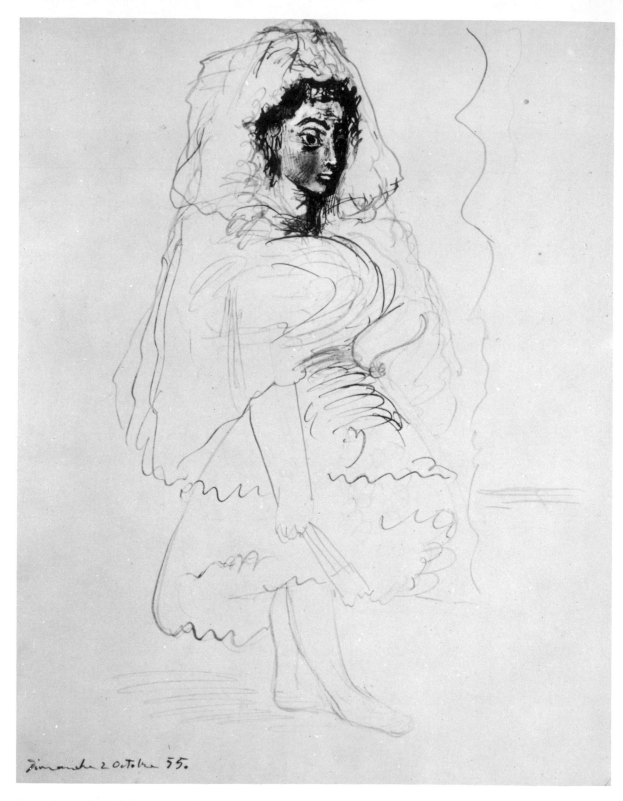

Jacqueline in Spanish Costume. *India ink and gouache, 26 x 20 inches. 1955*

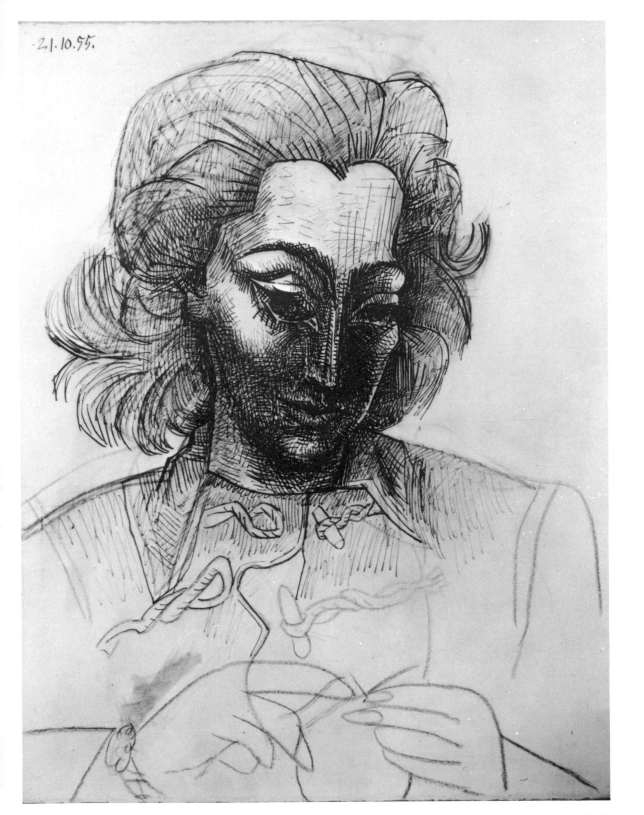

·21·10·55·

Jacqueline. *Charcoal and India ink, 26 x 20 inches. 1955*

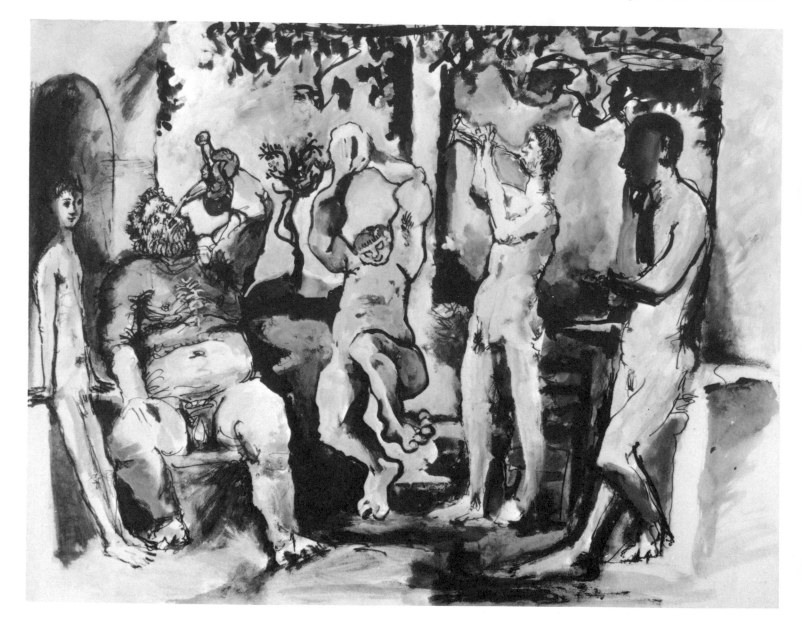

Bacchanal. *India ink and gouache, 20 x 26 inches. 1957*

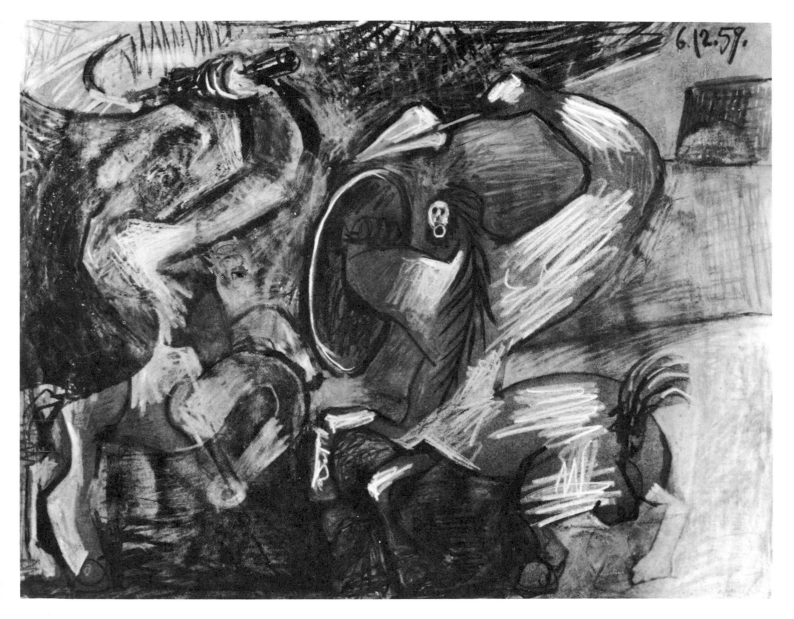

Battle of the Centaurs. Colored pencils, 19⅞ x 25¾ inches. 1959

Bathsheba
Pencil and colored pencils,
14⅝ x 10⅝ inches
1963

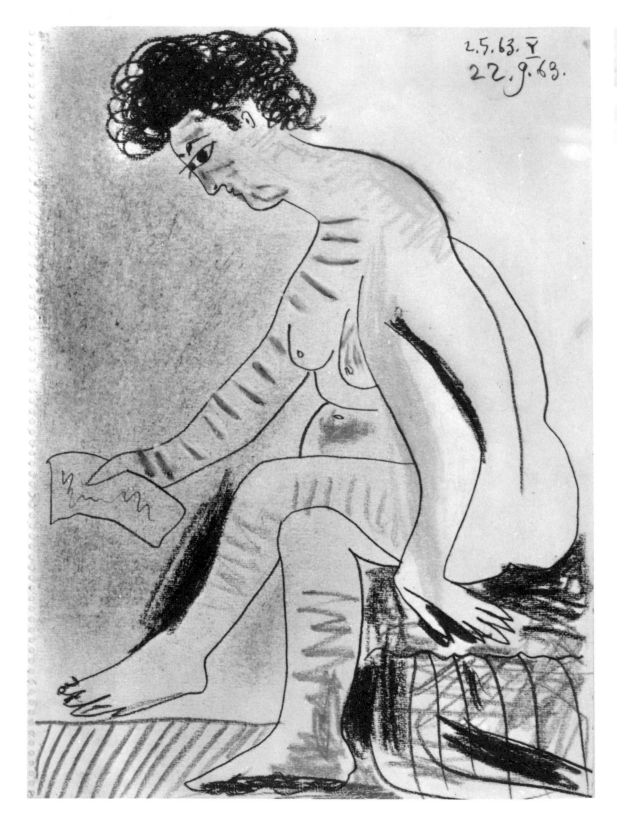

2.5.63. Ⅰ
22.9.63.

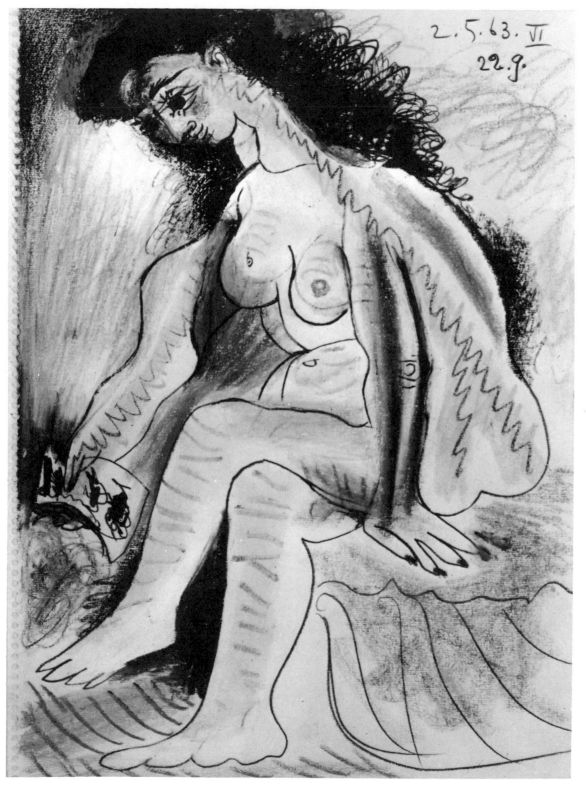

Bathsheba
Pencil and colored pencils,
14⅝ x 10⅝ inches
1963

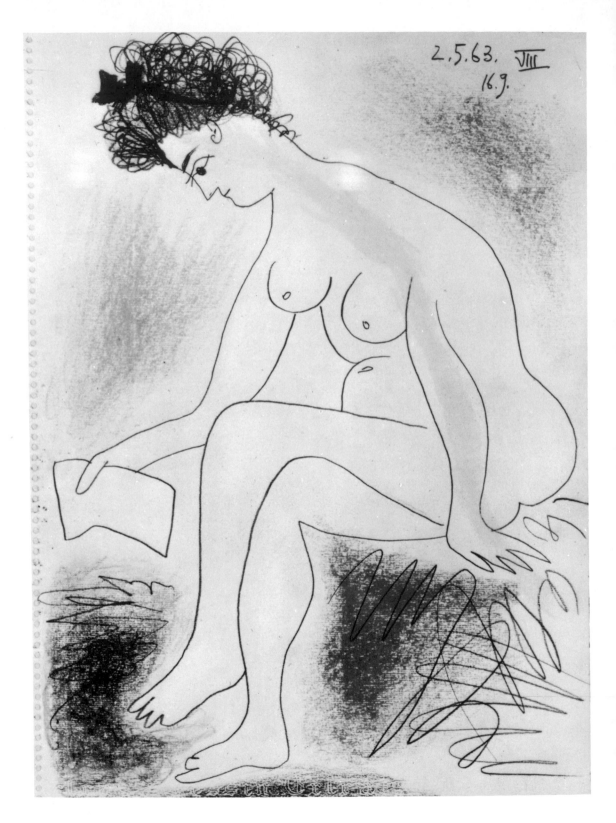

Bathsheba
Pencil and colored pencils,
14⅝ x 10⅝ inches
1963

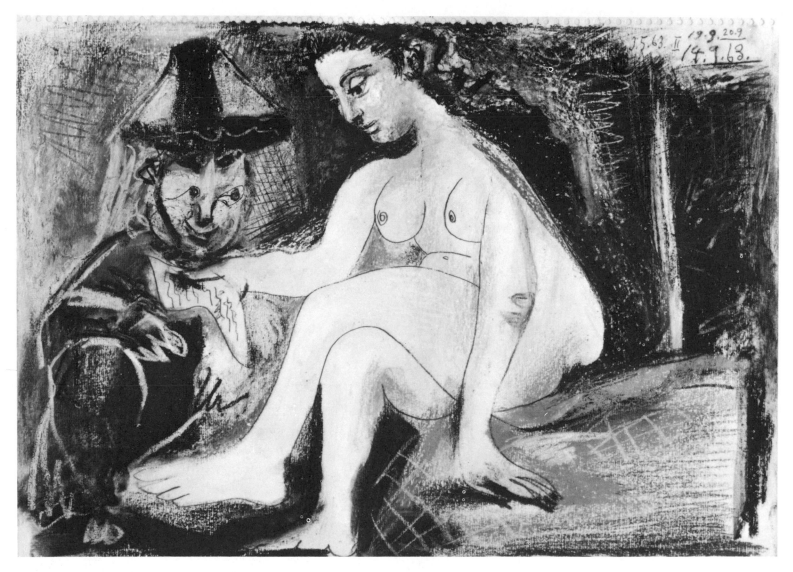

Bathsheba. *Pencil and colored pencils, 10⅝ x 14⅝ inches. 1963*

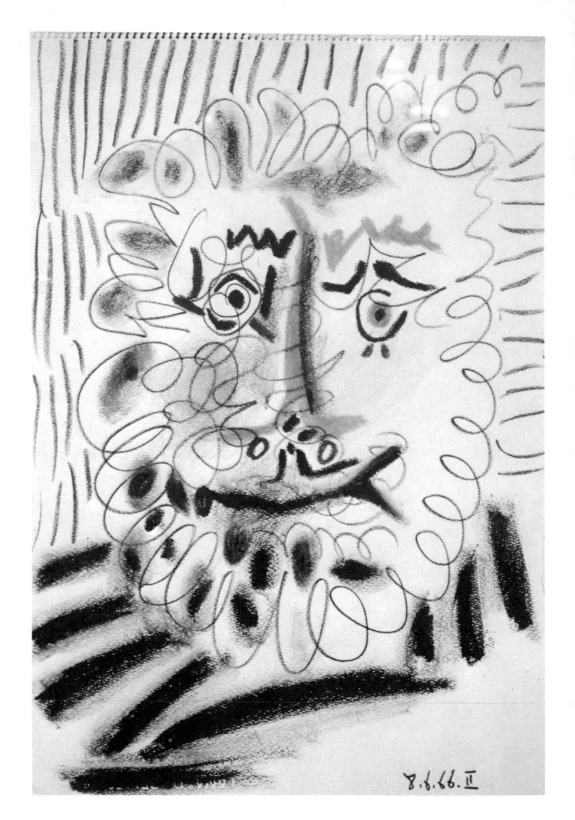

Head of a Man
Colored pencils,
21 x 14⅝ inches
1966

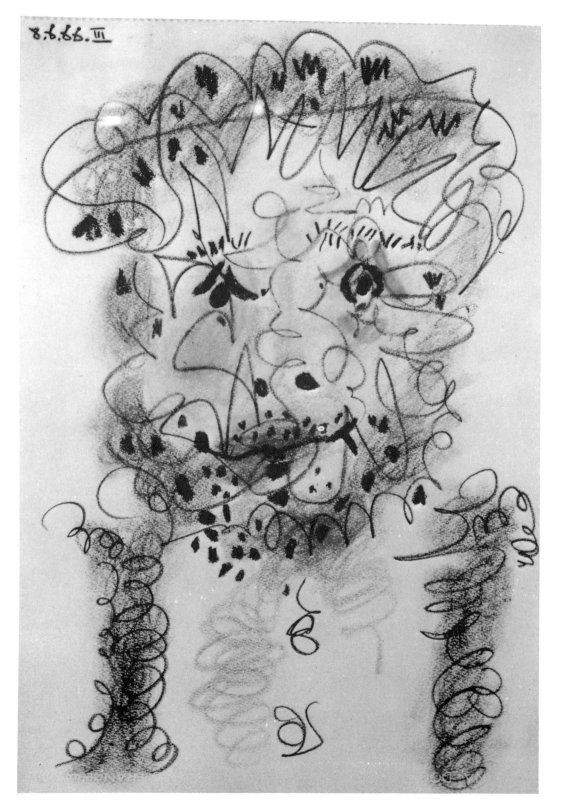

Head of a Man
Colored pencils,
21 x 14⅝ inches
1966

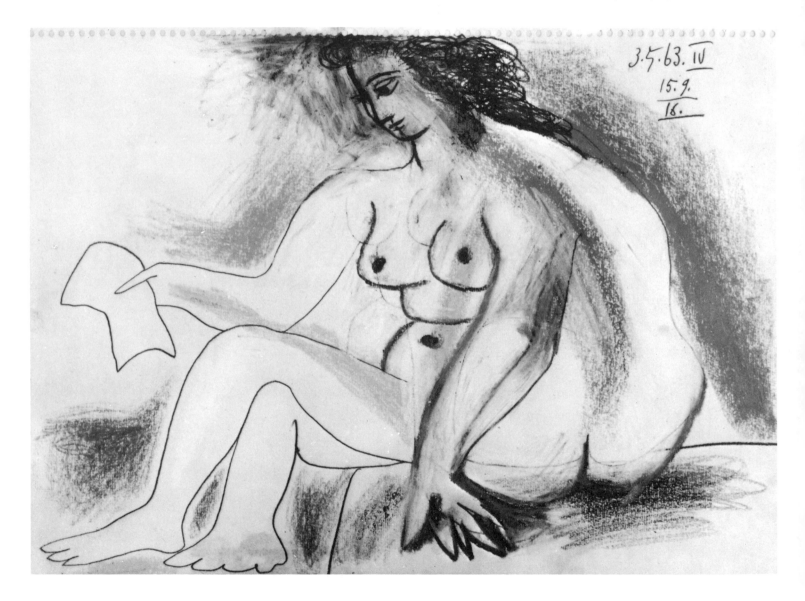

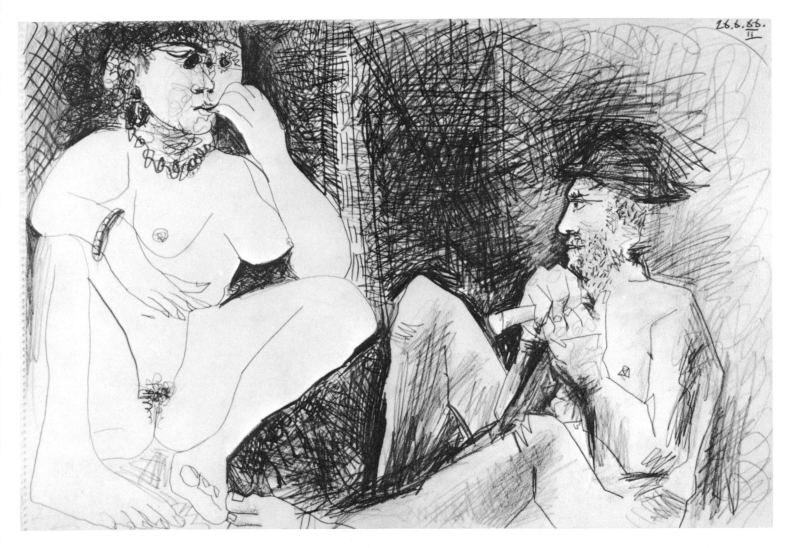

Old Man and Nude Woman. *Pencil, 14⅝ x 21 inches. 1966*

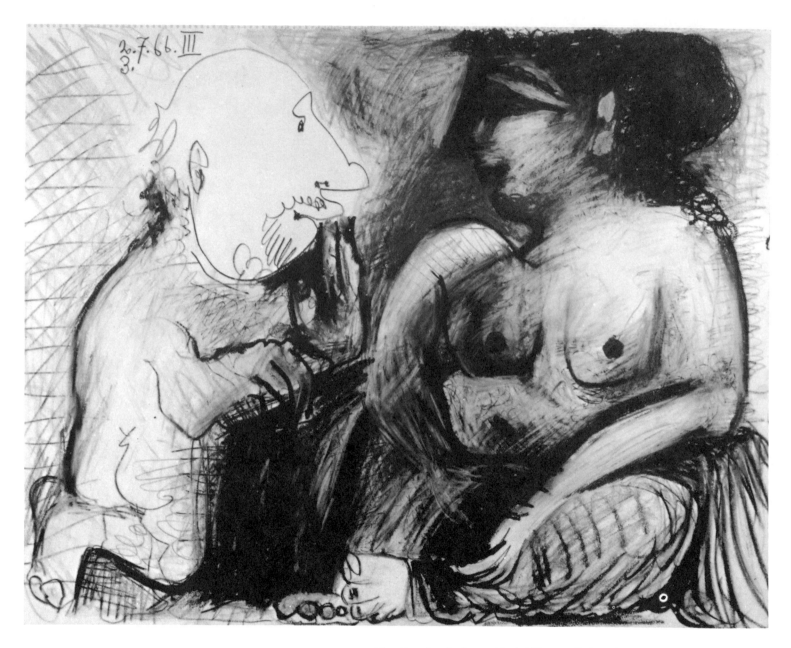

Man Kneeling before a Nude Woman. *Colored pencils, 19⅝ x 24 inches. 1966*

Two Nude Women. *Pencil and colored pencils, 19⅝ x 24 inches. 1966*

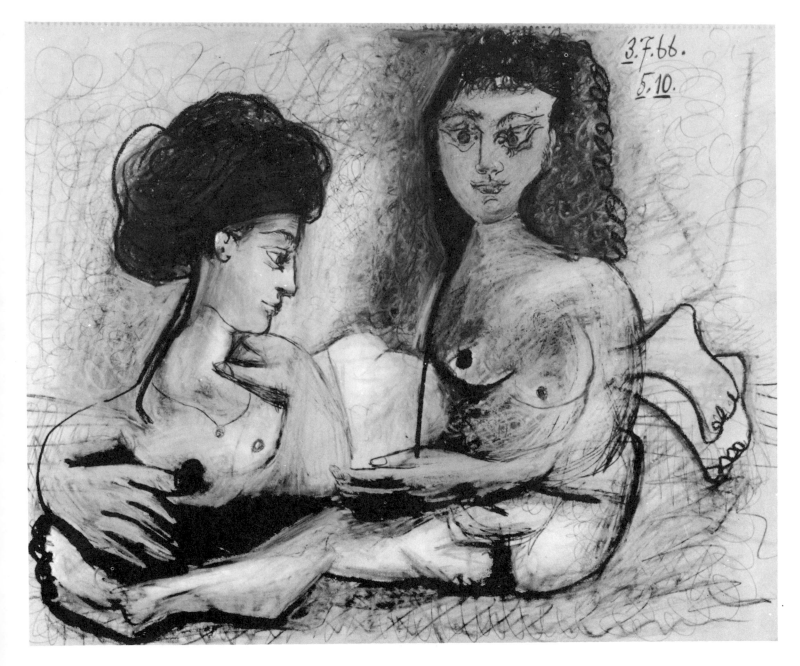

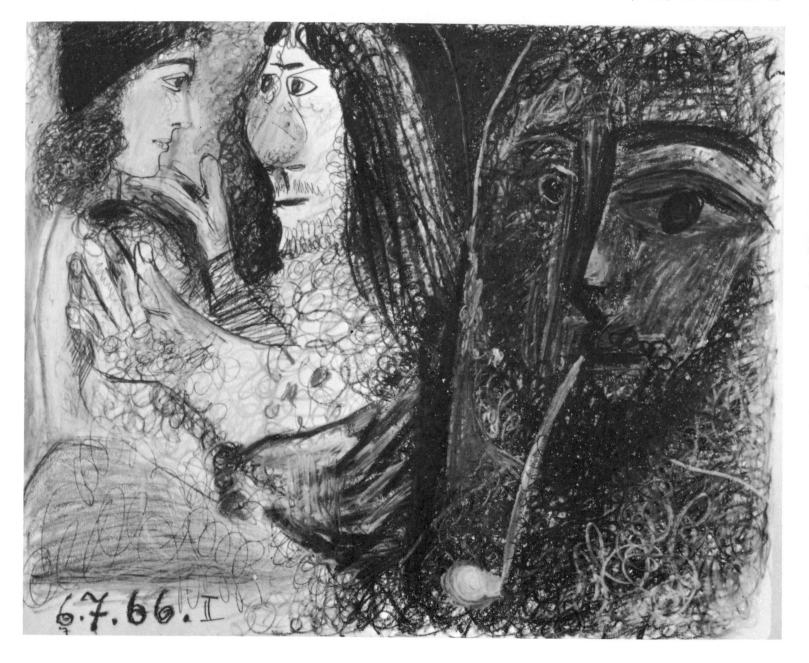

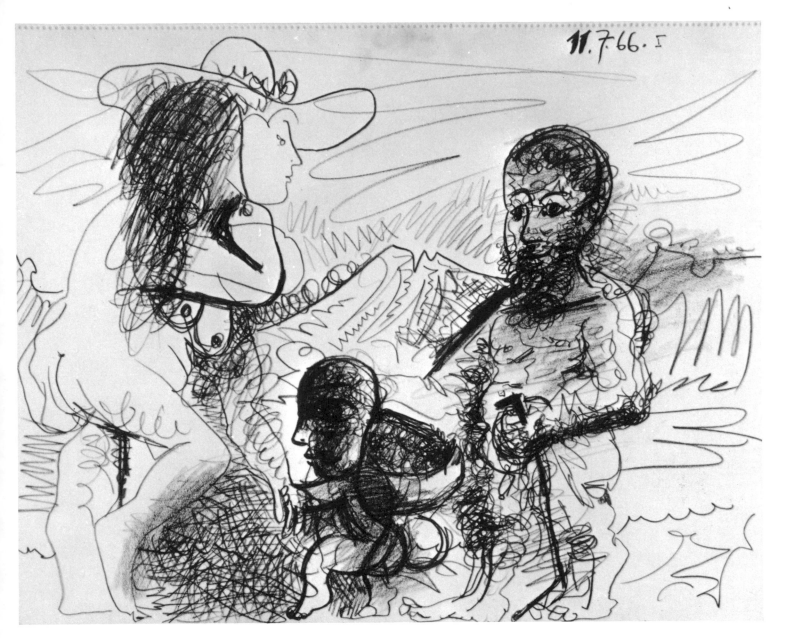

Man, Woman, and Child. *Colored pencils, 19⅝ x 24 inches. 1966*

141